WORTHING PUBS

DAVID MUGGLETON,
COLIN WALTON & JAMES HENRY

AMBERLEY

Foreword

This book deals with the seaside town of Worthing and its borough neighbourhoods of Salvington, Durrington, West Tarring and Broadwater. The five trails that form its main chapters cover a conurbation that is well connected by transportation routes and which is bounded by Limbrick Lane at the west, the A27 at the north and the B223 at the east. Due to limitations of space, the separate entries are confined to pubs that were in existence prior to 1970. Beer retailers and possible pubs for which little is known aside from the location are mentioned in the relevant chapter openings, as are the new breed of micropubs, which hark back to a traditional past with their emphasis on conversation, community and local produce. For further details on all forms of drinking establishments in a wider area than this book could cover, please visit the website www.worthingpubs.com, with which this book is a joint enterprise.

Information on brewery ownership of pubs is sometimes given in the relevant entry, although the major part of such ownership, where known, is normally identified by initials in brackets immediately following the address. The initials stand for the following breweries. BL: Black Lion of Brighton; BR: Brickwoods of Portsmouth; CH: Charrington of London; CO: Constable of Arundel and Littlehampton; EA: Eagle of Arundel; FR: Friary, Holroyd & Healy (later Friary Meux) of Guildford; FU: Fuller's of Chiswick; GA: Gale's of Horndean; KTB: Kemp Town of Brighton; PBU: Portsmouth & Brighton United; PO: Portslade; RO: Rock of Brighton; SM: Smithers of Brighton; ST: Steyning; TA: Tamplins of Brighton; TO: Tower of Worthing; TT: Three Tuns of Steyning; WG: Westgate of Chichester; WH: Whitbread of London; WS: West Street of Brighton; WT: Watney Tamplins. A dash between initials represents a known process of acquisition. The reader should find the seventh paragraph of the following introduction to be informative in this respect.

First published 2020

Amberley Publishing
The Hill, Stroud
Gloucestershire, GL5 4EP

www.amberley-books.com

Copyright © David Muggleton,
Colin Walton & James Henry, 2020
Maps contain Ordnance Survey data.
Crown Copyright and database right, 2020

The right of David Muggleton, Colin Walton &
James Henry to be identified as the Authors of this
work has been asserted in accordance with the
Copyrights, Designs and Patents Act 1988.

ISBN 978 1 4456 8802 2 (print)
ISBN 978 1 4456 8803 9 (ebook)

British Library Cataloguing in Publication Data.
A catalogue record for this book is available from
the British Library.

Origination by Amberley Publishing.
Printed in the UK.

Contents

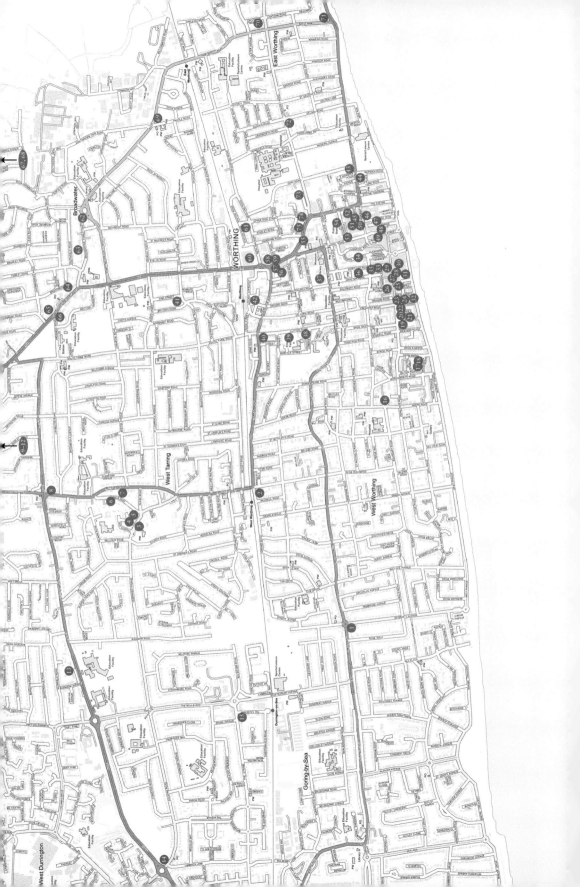

Key

Introduction

Before its growth from the late 1700s, Worthing was a small agricultural hamlet with a smattering of fishermen. Its oldest known tavern was the Sea House, so named by local victualler Thomas Wicks, who acquired it as one of a pair of cottages by 1762. It was situated on the foreshore opposite what is now Bedford Row, but was washed down on the sands in December 1772 and abandoned. A new Sea House Inn under proprietor Thomas Hogsflesh was built *c*. 1783 on the south-west corner of South Street (then Worthing Street). It received a two-storey extension in 1789 and was further enlarged in 1811. It was afterwards demolished and replaced on the same site by a Regency-style Sea House Hotel designed by leading local architect John Rebecca. The opening dinner was held on Monday 30 October 1826 under the auspices of proprietor George Parsons. It became the Royal Sea House Hotel after Queen Adelaide, widow of William IV, stayed there in May–June 1849. The Royal Hotel, as it became more simply titled, was destroyed by a fire that began in the early morning of Friday 24 May 1901. The Royal Arcade of 1925 now occupies the site.

In 1789, the New Inn was opened on the opposite, south-east corner of South Street under proprietor James Austin. By April 1824 it was acquired by Oliver Hillman, who much enlarged it with a Regency bow frontage and by June 1825 had renamed it the Marine Hotel. Queen Victoria stopped to change horses there in 1842 and again in 1845. Adjoining the Marine Hotel and on the south-west corner of Marine Place, what in 1814 had been Marine Cottage became the Wellington Inn (or sometimes Duke of Wellington Inn) in 1819 under James Wicks. It was subsequently rebuilt in three storeys and in 1862 was renamed the Pier Hotel. By that point the transformation of Worthing was complete. During the second half of the eighteenth century it had gradually attracted visitors due to a developing belief in the health-giving properties of sea air and bathing. In August 1798, Princess Amelia, daughter of George III, began a five-month stay to cure an injured knee, during which she was visited by her brother, the Prince of Wales, from his residence at the Royal Pavilion, Brighton. This royal patronage acted as the catalyst for the development of Worthing into a fashionable resort. It acquired town status in 1803 when its administration was invested in a Board of Commissioners who first met at the Nelson Hotel, South Street, on 13 June that year.

The opening of the Steyne Hotel on 1 July 1807 provided further accommodation and entertainment for select and stylish visitors. Its elegant facilities included a public coffee room, sitting rooms and a ballroom with card rooms. The first subscription ball in the town took place there in November 1814. From the mid-1820s onwards, however, this social whirl of

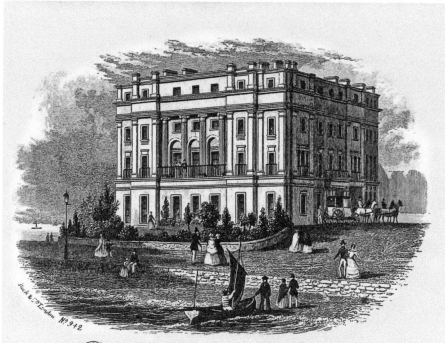

Royal Sea House Hotel Worthing

JOHN FOWLER,

Respectfully informs the NOBILITY and GENTRY who honour WORTHING with their presence, that they can be entertained at the above HOTEL, with every attention to their comfort and convenience.

FAMILIES may be accommodated with any number of Rooms, on moderate Terms.

COMMERCIAL GENTLEMEN also will meet with the greatest attention in the above Establishment.

J. F. has always in his Cellars a Stock of first-rate WINES and SPIRITS, BOTTLED ALES and STOUT.

FAMILIES provided with DINNERS from the HOTEL at their own Residences.

Royal Sea House Hotel. (Phillipp's Handbook & Directory of Worthing, 1849. Courtesy of West Sussex County Council Library Service, www.westsussexpast.org.uk)

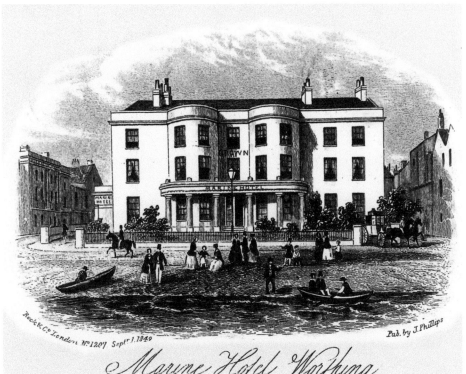

Marine Hotel. (Phillipp's Handbook & Directory of Worthing, 1850. Courtesy of West Sussex County Council Library Service, www.westsussexpast.org.uk)

To Commercial Travellers, Visitors, and Others.

---o---

WELLINGTON INN,

WORTHING,

Adjoining the Marine Hotel,

Pleasantly situated by the Sea-side, with comfortable Apartments for small families, and good accommodation for travellers, on most reasonable terms.

Excellent Wines and Spirits, and Well-aired Beds.

PROPRIETRESS - - - - Mrs. BECK

Wellington Inn. (French & Watkis's Handbook & Directory for Worthing, 1857. Courtesy of West Sussex County Council Library Service, www.westsussexpast.org.uk)

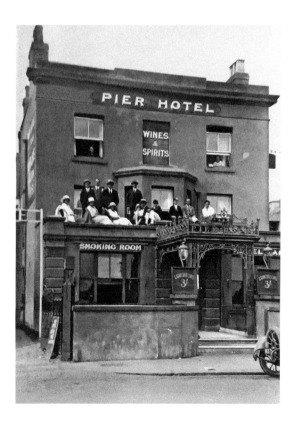

Pier Hotel. (Courtesy of Nicola Chapman)

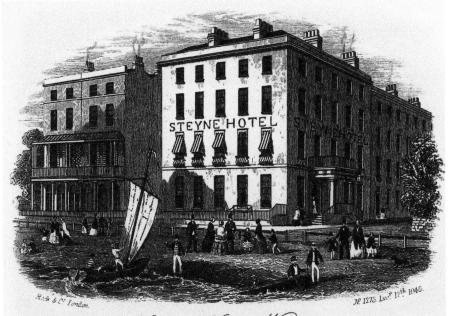

Steyne Hotel Worthing

S. T. BENNETT,

Proprietor of the above, in soliciting the patronage of Visitors to this highly-favoured Watering-place, which the Board of Health has stated to be the second most healthy place in England, begs to state that nothing can possibly exceed the cleanliness and comfort of the STEYNE HOTEL, as a reputation of Twenty Years will testify. The Eastern aspect has a commanding view of the Steyne Gardens, while the South has an uninterrupted view from Beachy Head to the Isle of Wight, and being the largest proprietor of houses,—having now twenty-five,—Families requiring houses, by writing or coming to the STEYNE HOTEL will obtain every information required gratuitously. The Augusta Place Houses he has just taken and fitted up in the best style.

———o———

BOARD AND LODGING IN THE HOTEL ON THE MOST MODERATE TERMS.

Steyne Hotel. (Phillipp's Handbook & Directory of Worthing, 1850. Courtesy of West Sussex County Council Library Service, www.westsussexpast.org.uk)

well-to do company, centred on theatres, libraries and assemblies, began to steadily fall out of fashion. Hence, we turn our attention away from the aforementioned hotels to the more prosaic public houses. Prior to the passing of the 1830 Wellington Beerhouse Act, the town had just five pubs. The Anchor in the High Street was the oldest, known by 1798; the Spaniard Inn, Chapel Street (subsequently Portland Road), was erected *c.* 1808; the Royal George, Market Street, very likely 1810, certainly by 1812; the Rambler Inn, West Street, was known by 1818; and the aforementioned Wellington Inn was the fifth oldest, 1819. Further out were the White Horse at West Tarring, by 1610; the Maltsters Arms at Broadwater, by 1785; the Lamb at Durrington, by 1809; and the Half Moon at Salvington, by 1823.

Of the beerhouses spawned in the area under the 1830 Act, several went on to acquire an alehouse (i.e. full or publican's) licence. Beer retailers who were refused an alehouse licence in August 1836 and who are not referenced in the remainder of this book were as follows: Mary Greenfield of No. 4 Gloucester Place; Samuel Grover, eating house keeper of South Place; James Sewell of South Street, supplied by the Eagle Brewery of Arundel; James Holden of No. 1 West Street and John Cuddington of No. 19 West Street. The arrival of the railway in 1845 did not lead to the prompt development of several newly built or newly licensed premises in the immediately vicinity, although it did bring about the transmogrification of the Crown Inn into the Railway Hotel and probably gave impetus to the 1848 opening of the nearby Norfolk Inn. The significant increase in drinking premises in the town occurred instead in the brief period of

West Worthing Hotel. (Kirshaw's Worthing Directory, 1877. Courtesy of West Sussex Record Office)

1865–71, with the addition or first known recording of ten alehouses and three beerhouses plus the opening on the seafront parade of the new Heene Hotel (renamed the West Worthing Hotel in 1867 and the Burlington Hotel in 1889).

 Successive parliamentary Acts from 1869 gave local magistrates greater powers to refuse icence renewals for pubs and beerhouses seen as surplus to requirements in their area of jurisdiction. While this led to continuous contraction at the national level, the overall situation in Worthing and its wider neighbourhoods was one of virtual stability even up unto the beginning of the Second World War. This was all the more unusual given the considerable presence of temperance activists in the town – at least ten coffee taverns and six temperance hotels traded at some point during the 1880s and 1890s. Certainly there was some transition in the local pub scene. In the area covered by this book, the period 1882–1939 saw a dozen licensed premises closed and eleven opened, although in eight cases brewery consistency was maintained by a licence transfer from the redundant house to the new one. Of the remaining four losses, two were beerhouses closed as a condition for the granting of permission to the brewery to build a new fully licensed house. The sacrifice through this means of the King & Queen at Heene by the Portslade Brewery enabled the construction of the most ornate pub in Worthing. Opened in 1900, directly opposite the central railway station, the Central Hotel, with half-timbered gables and octagonal corner turret with pineapple ogee and finial, marked the high point of the golden age of pub building. The same brewery also remodelled their Alexandra Hotel in Lyndhurst Road in grand classic style during this period.

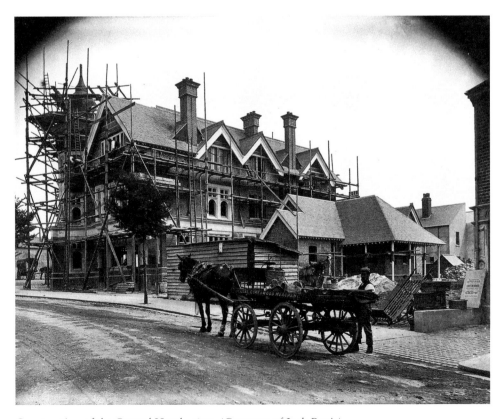

Construction of the Central Hotel, 1899. (Courtesy of Jack Regis)

A movement towards public house reform and respectability that began during the late nineteenth century culminated during the interwar period in the 'improved public house'. Based on a philosophy of 'fewer, bigger, better', the intentions were to promote sobriety, widen the clientele class base and create more welcoming family environments. The need for improved pubs was also fuelled by the rapid growth of suburbanisation and a corresponding increase in car ownership, for this era of modernity was also that of the motorist. The construction of arterial roads more directly connected the town to what had once been separate outlying small villages and settlements. The Dolphin Hotel at East Worthing, the George Hotel in Goring Road and the Downlands Hotel on the Upper Brighton Road were newly built in the style of the classic 'roadhouse' with draw-ins for motorcars. The latter was promoted in the local press as a place where the traveller between Brighton and Portsmouth could stop for refreshment and a good meal. As well as the provision of new premises, many pubs in the area were rebuilt during this period in Queen Anne, neo-Georgian, Brewers' Tudor or art deco style – an example of the latter being the Pier Hotel in 1937–38.

By 1955, decades of brewery mergers and takeovers had left fifty-one out of then extant fifty-eight of the pubs and hotels covered in this book in the estates of just four breweries. Charrington of London held eighteen via their purchase the previous year of the Kemp Town Brewery of Brighton. Another seventeen were tied to Watney Tamplins, an outcome of Tamplins of Brighton having been taken over in 1953 by the London brewery Watney, Combe, Reid, subsequently Watney Mann. Brickwoods of Portsmouth held ten and the remaining six were owned by Friary, Holroyd & Healy of Guildford. The following chains of acquisition account for most of that outcome. The Kemp Town Brewery acquired the local Cannon Brewery *c.* 1894, the Portslade Brewery in 1919 and the local Tower Brewery (formerly Egremont Brewery) in 1924. The Rock Brewery of Brighton purchased the Black Lion Brewery of that town in 1911 and the Steyning Breweries in 1919, the latter having been created though an 1898 merger of the Michells and the Three Tuns Breweries. Rock was acquired in 1927 by Portsmouth United Breweries to form Portsmouth & Brighton United Breweries, who were themselves taken over in 1954 by Brickwoods. The Constables of Arundel merged in 1921 with Henty & Sons of the Westgate Brewery, Chichester, to form Henty & Constable. Their Westgate Brewery was closed in 1955 and the tied houses divided between Watney Tamplins and Friary, Holroyd & Healy. Tamplins had long before acquired the West Street Brewery and the Smithers Brewery of Brighton, while Friary had purchased the local Montague Brewery in 1889, the Eagle Brewery of Arundel in 1910, and the Vine Brewery at West Tarring in 1938.

More brewery consolidation was to follow in the 1960s and 1970s when Watney Tamplins became part of Grand Metropolitan, Friary Meux was subsumed into Ind Coope under Allied Breweries, while Brickwoods was acquired by Whitbread of London. Yet the greatest threat to Worthing's pub scene was not so much the reduction in cask-conditioned beer choice following the imposition of national keg brands, but what has been called the 'philistine' policies of its own town planning department. To put it into its proper context, the 1960s was the futuristic decade where the past was seen to stand in the way of progress and Worthing was just one of many towns and cities thus blighted. Yet the anger felt by some of its residents over those reviled redevelopment schemes is palpable even today. The Running Horse in Paragon Street was replaced in 1962 by the rear of a new supermarket and the street razed to the ground for the Grafton multistorey car park. Similarly, in 1969, both the Dragoon and the Royal George were closed and eventually demolished along with most of Market Street for another such car park and the Guildbourne Shopping Centre. The seafront Marine and Pier hotels were both closed by Watney Tamplins on Saturday 17 July 1965 and subsequently demolished. A new Marine pub was opened by the brewery to great ceremony on part of the old site at 1 p.m. on 14 April 1967

– a squad of Royal Marines specially attended from Portsmouth – but the boxy modern design was later criticised as reflecting a 'Lego-Brick mentality' that created a 'Costa Brava skyline'. In all, nine pubs and hotels were lost during that decade. Only the first to close – the Nelson, in 1960 – escaped demolition.

The new Marine pub was one of six more to be lost in the period 1979–87 but the replacement of old-fashioned backstreet boozers by trendy bars populated by young people, whose custom is crucial to the night-time economy, really began apace with the new millennium. By 2001 a new breed of so-called 'superpubs' – Café Central, Toad, Yates's Wine Bar and the Sir Timothy Shelley – were occupying large, former shop premises in Chapel Road. Another sixteen or so traditional pubs have closed since then, while those that still thrive – the Hare & Hounds, Selden Arms and the Rose & Crown, for example – will co-exist alongside contemporary bar equivalents such as the Beach House, the Libertine and the Goose, for this postmodern era is of one of pluralistic tastes. Another outcome of the deregulated drinking landscape has been the micropub, with its selection of real ales from local microbreweries. Several micropubs have opened up in the area since Anchored in Worthing led the way in August 2013. The cask-conditioned offerings of café-bars, micropubs and traditional pubs, along with the refurbishment and reopening of former stalwarts such as the Corner House (originally the Anchor) and the Egremont, were celebrated in an autumn 2016 *Sussex Drinker* CAMRA (Campaign for Real Ale) magazine article by Stuart Elms, entitled 'Worthing – a new Real Ale Mecca in Sussex'. That is something to raise a glass to.

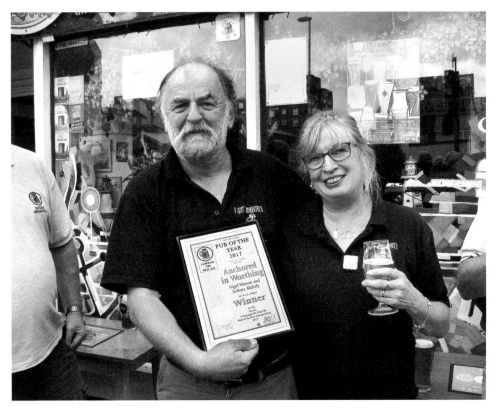

The CAMRA award-winning Nigel and Deborah of Anchored in Worthing.

West Worthing, West Tarring and Durrington

We begin this trail in Goring Road, where at No. 54 Craig Stocker and Helene Quignot opened the Georgi Fin micropub on 23 June 2017. The name is after the couple's two children. On the north side of West Worthing railway station at No. 17 South Street, Les Johnson opened the Green Man Ale & Cider House micropub on 7 October 2016. Four alehouses, an inn and a tavern were recorded in West Tarring in the 1630s. Approaching Durrington, we find the Fox & Finch micropub at No. 8 Littlehampton Road, opened by Mike and Jo Saveen on 19 July 2019.

1. Toby Carvery, No. 39 Goring Road, West Worthing (KTB-CH)

As the George Hotel, this was built by Rice & Son Ltd to a Denman & Son design, both of Brighton. The year 1933 appears on the rain heads of no less than seven drain water pipes arrayed around the building and its licence was granted in July of that year. A bow-fronted wine office then faced Goring Road and a private bar, bottle and jug and public bar with saloon bar behind ran north to south along George V Avenue. Gwendoline Barraclough, a dancer who had studios near Baker Street, London, held classes for children here in 1935. The Worthing branch of the Royal Naval Old Comrades Association held their inaugural meeting here in April 1938. The president, Admiral Geoffrey Hopwood CBE, was 'piped aboard' as he entered the room and 'piped ashore' when he departed. On the evening of Friday 15 December 1950, Charles James Douglas Southcliffe – the hotel's first landlord – had to break down the locked door of guest Mrs Dorothy Gladys Cary, who had accidentally set herself alight. The sixty-seven-year-old composer died in hospital on Christmas Day from the effects of toxic absorption. In 1979, this became the first Bass-Charrington Toby Inn with steak bars in the south, giving rise to its current name. The history of the house could have been otherwise, for it was originally to be called the Elm Tree and to stand several hundred yards eastwards on the junction with Elm Grove (subsequently Wallace Avenue) but that site proved unsuitable.

2. Downview, No. 1 Station Parade, Tarring Road, West Worthing (KTB-CH)

Built by J. W. Hobbs & Co. Ltd of South London to a design by Scott & Co. of Brighton, this new hotel was required to cater for the rapidly developing neighbourhood and the passengers using the adjacent West Worthing railway station that had opened on 4 November 1889. The Downview was trading by 17 December 1890 under Londonderry-born landlord John Sinclair.

Toby Carvery – originally the George Hotel.

Downview, 22 October 2014.

The West Worthing Tradesmen Association had established their headquarters here by 1912. A billiard room was constructed in a first-floor extension at the west to plans of May 1922 and alterations of 1928 by Denman & Son included the provision of a wine office at the south. The newly formed West Worthing Football Club made the hotel their headquarters in 1931. The Far East Prisoners of War Association; the Old Azurian Trades & Professions Club; the Rotary Club and its sister organisation, the Inner Wheel; the Camera Club; the Gramophone Society and the Liberal Association all met here during 1956–58. The diverse range of entertainment that could be enjoyed here in March 1994 included karaoke, a beach party with surf simulator, a jazz band and a darts exhibition by Bobby George. The pub closed for the final time on 16 July 2017 and is currently being converted to accommodation for those most at risk of homelessness.

3. Ship, Nos 40–48 Church Road, West Tarring
A tenement on this site was probably an inn during 1643–50 when it was called the Ship. It was converted to five cottages *c.* 1839, and these were demolished in 1888.

4. Black Lion, Nos 69–73 Church Road, West Tarring
A house on this site was probably an inn during 1674–1760 when it was called the Black Lion. The name was changed to the Black Horse by 1770 and it continued as such until being rebuilt in 1840 as the three cottages that now occupy the site.

5. George & Dragon, No. 1 High Street, West Tarring (TA-WT)
Known by 1610 as the White Horse under Moses Brian, it became the George by 1781. The present Grade II listed building is of the mid-eighteenth century. Although 1855 provides the first reference to it as the George & Dragon, the George Inn name (sometimes the St George Inn) remained in common local usage until the 1890s. In the early nineteenth century the inn was said to have doubled as an excise office and was associated with preventative men but infiltrated by smugglers. The West Tarring Club celebrated their twentieth anniversary in May 1856 by attending divine service, then perambulating the village with band and banners before dinner at the inn. Rather than swinging downwards, the pub sign is bracketed upright. It was first positioned this way in 1927 to prevent collisions with the double-decker buses that mounted the pavement at this tight turn to avoid oncoming traffic in the narrow street. The local Combined Ex-Service Association met here in October 1953.

The Landlords
Dorothy Caroline Stanford retired as the landlady of the George & Dragon on 30 November 1965. She had held the licence since the death in 1947 of her husband Albert Edward Stanford. Albert had been the landlord since just after their marriage in 1935 and had taken over from Dorothy's mother, Emily Rosetta Norris, who had been the landlady since the death in 1932 of her husband, Alfred Charles Norris. Alfred was a councillor and former newsagent who had taken the George & Dragon in 1906, having moved from the close by Castle Inn. He had been the landlord at the Castle Inn since 1903, having followed his mother, Caroline, who had retired due to poor health. She had been the landlady there since the death in 1892 of her husband, Luke Norris, who had been the landlord since *c.* 1864.

George & Dragon – originally the White Horse.

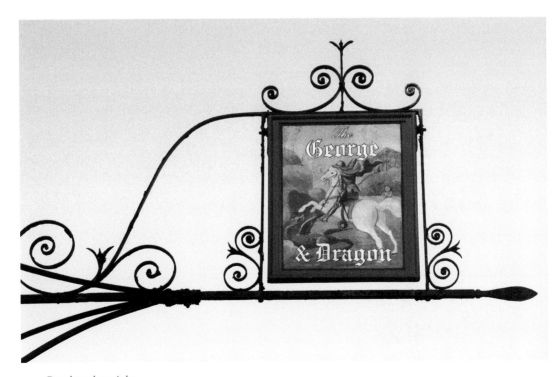

Bracketed upright.

6. Vine, Nos 27–29 High Street, West Tarring (FR)

The original building behind the Victorian façade probably dates back until at least the seventeenth century. This was the home from 1843 until 1938 of the Parsons brewing family. The free house and brewery were sold at auction in May 1938 for £6,350 to Friary, Holroyd & Healy Brewery of Guildford. The following month their Estate Department drew up plans for alterations that left the pub with its present single, central front entrance, instead of the three former bays that each had their own doorway. Frederick William Glover Wilson, the new licensee of July 1938 was granted a wine licence in May 1939 and a full licence in February 1952. A former freelance photographer of Bognor, he was appointed official photographer to the royal family when George V convalesced near that town in 1929. The Vine became a free house once again with its 1984 purchase by John Chambers. On 24 February 1998 it became part of the tenanted estate of Hall & Woodhouse Brewery of Blandford, Dorset. The current licensee is Gary Cox, whose pubs since the late 1980s include the George & Dragon (twice), John Selden, Swan, Castle Tavern and the Half Brick. Brewing at the Vine was revived in 2017 with a beer fittingly called Parsons First Brew.

The Local Brewers

Richard Parsons (1792–1871) was born in West Tarring and moved to this house in 1843. On his retirement in the early 1860s he was succeeded as brewer and beer retailer by his son, Henry, a journeyman carpenter by trade. A report of Henry's death on the premises on 9 December 1872, aged forty-four, provides the earliest known reference to the Vine Brewery name. His son, another carpenter named Henry, took over the business and remained here until his death on 8 August 1937, aged eighty-two. He had additionally worked as a shingler but retired from this occupation seven years previously, his last job having been the repair of the spire of the village church.

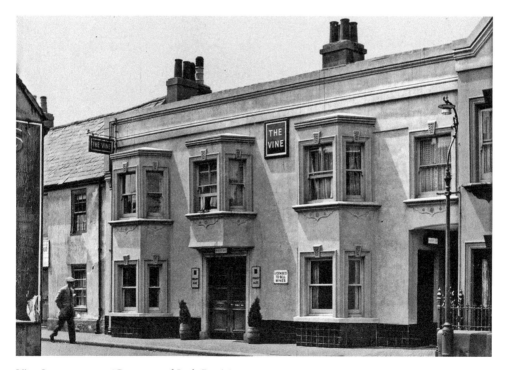

Vine Inn, *c.* 1940s. (Courtesy of Jack Regis)

7. Castle Inn, No. 26 High Street, West Tarring (TA)

A cottage on this site in 1638 was developed into an inn that had opened for business not much earlier than 1762. The West Tarring Society for Prosecuting Felons, Thieves and Other Offenders held their annual meeting here in June 1814. The West Tarring Provident Benefit Society met and dined here in the 1850s and 1860s, as did on various occasions in the 1890s the Bonfire Society, the Cricket Club, and the churchwardens accompanied by the choir and bellringers. In December 1909 the licence was transferred to a brewery representative in preparation for its removal to new premises to be called the St Thomas á Becket. The Castle Inn subsequently became a private house, but the old lantern sign remains above the front door.

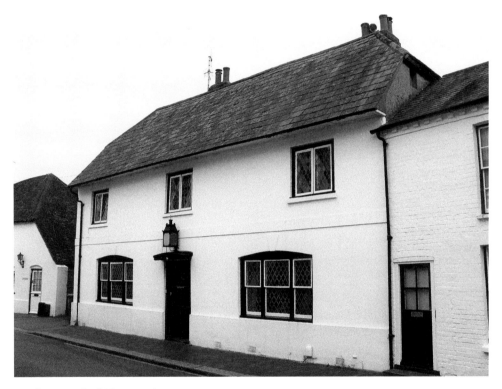

Castle Inn with old lantern sign.

8. Thomas á Becket, No. 146 Rectory Road (TA-WT, GA-FU)

This new hotel opened in March 1910 under landlord Councillor Ernest Anscombe Brackley. Built by Brown & Sons of Brighton, the half-timbered design by local architects Singer Hyde & Son was intended to reflect the medieval Parsonage Row cottages in the High Street. The name is after the twelfth-century Archbishop of Canterbury who, entirely according to local legend, visited the Old Palace in West Tarring and planted the first fig tree in the locality. A club room originally stood at the north along the Rectory Road elevation with a wine shop at the south. Between these was a three-partitioned bar – public, bottle and jug, private – with a smoking parlour behind. The saintly name prefix was dropped in 1913. A semicircular castellated wine office was erected at the north in 1931. The West Tarring Bowling Club played on the green at the rear from 1924 to 1957. The local Canadian Veterans Association established their

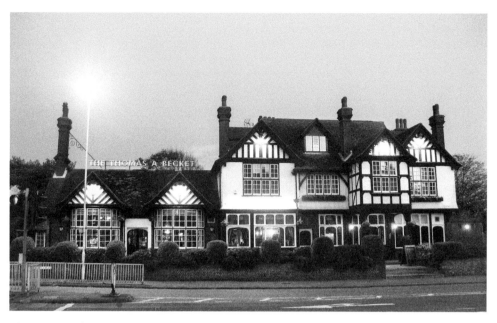

Thomas á Becket by twilight.

St. Thomas à Becket Hotel,

TARRING, WORTHING.

Situate near Golf Links and foot of Downs.

GOOD ACCOMMODATION for VISITORS. LARGE GROUNDS.

THE NEW BOWLING GREEN WILL SHORTLY BE OPENED.

Wines, Spirits and Ales of the choicest quality.

GARAGE.

E. A. BRACKLEY, Proprietor.

TELEPHONE, 254 NAT.

JINKS' 'BUS FROM TOWN HALL, WORTHING, TO DOOR.

Originally saintly. (Kelly's Worthing Directory, 1911–12. Courtesy of West Sussex Record Office)

headquarters at the hotel after the Second World War. An April 1968 refit gave the interior a medieval theme, including tapestry, armoury and a portcullis. It was the idea of landlord Donald Hodson who was a former New York interior designer. In a refit of 2011, the ex-wine office was removed and a roof sign reinstated – a feature of the original building.

9. Spotted Cow, Half Moon Lane, Salvington (EA)

Elizabeth Henson began brewing and beer retailing at this cottage as a means of income after the death of her husband in 1850. By 1859 it had become the worse conducted house in the district under Stephen Slaughter Swan, who was fined in March of that year and again the following April for opening outside permitted hours. On 26 October 1881, the wife of landlord Frederick Seymour Smart gave birth to twin daughters. In February 1908, the case was dismissed against landlady Frances Ellen Ansfield, who had been summoned for knowingly selling stout to a child under fourteen years of age. The beerhouse licence was given up without compensation in 1910 after it was agreed that the full licence of the nearby Half Moon would be transferred to newly built premises on this site.

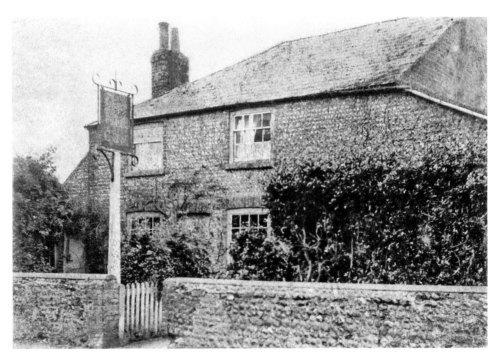

Spotted Cow. (Courtesy of West Sussex County Council Library Service, www.westsussexpast. org.uk, PP-WSL-L000476)

10. John Selden, Half Moon Lane, Salvington (EA-FR)

As the John Selden Arms, this was newly built on the site of the Spotted Cow to open in December 1910 under landlord Samuel Sandham. The plans by Singer Hyde & Son show the porch entrance at the south leading to a sitting room with a club room to the west and a public bar at the east with taproom behind. A new timber-framed club room abutting at the west

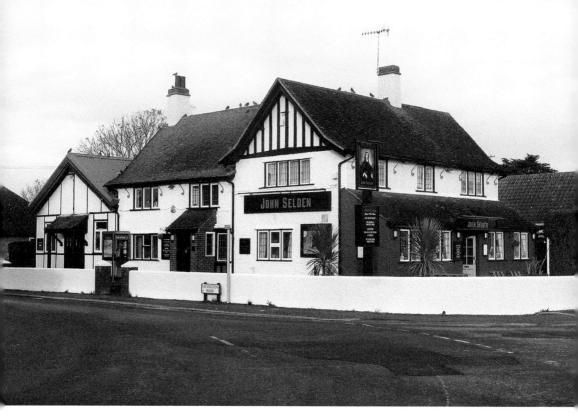

John Selden – opened 1910.

was formally opened on Thursday 21 October 1926 by the revival of the annual dinner of the Durrington Athletics Club. The pub name is after the political activist, jurist and philosopher who was born in a Salvington cottage in 1584. The new signboard of August 1950 erroneously conferred a knighthood upon him and had to be corrected that December. The Worthing Eagle Motor Club met here in March 1958. The old well that was revealed outside the pub in June 2012 when the high-heeled shoe of a female customer pierced the tarmac, had probably provided the brewing liquor for the Spotted Cow.

11. Half Moon, No. 11 Half Moon Lane, Salvington (EA)
This was a public house by May 1823 when it was 'burglariously entered by villains who stole fifty pounds in silver and all the last new coinage and escaped with their booty'. The name was derived from the shape of the pond at the front of the house. The last landlord was Leon Alexandre Pierre, who during his time here from 1896 oversaw annual invitation dances and slate club dinners. After the licence was transferred in 1910 to the John Selden Arms, the Half Moon premises doubled as tea gardens and a laundry. Half Moon House is today a Grade II listed private residence. The pond has long since dried up and is now covered by the road.

12. Park View, Salvington Road, Durrington (TA-WT)
As the Lamb Inn, this was first mentioned by name in 1809 but may have existed as early as 1740 and we hear that in 1769 two Durrington men were fined for drinking in the public house during the period of divine service. An Inclosure of Lands meeting was held here in August 1814. It was not always an orderly house. The licence renewal had been refused in 1867 due to the

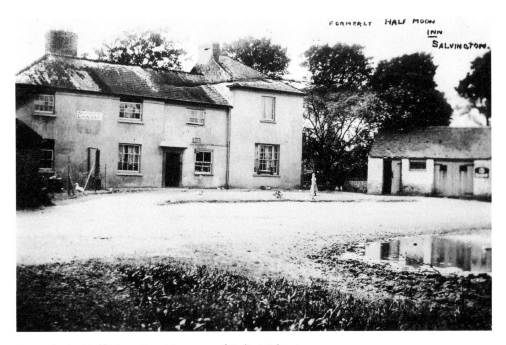

Formerly the Half Moon Inn. (Courtesy of Colin Walton)

bad conduct of landlord George Henson. He had been fined in September 1855 for keeping his house open for the sale of beer during prohibited hours on a Sunday and repeated the offence in December 1861. When up before the bench on that latter occasion, he and his wife made remarks of a violent nature to the constable who had brought the charge. Mrs Henson was ordered to leave the court but departed voluntarily while continuing to harangue and accuse the policeman. In April 1887, a young man was sentenced to six weeks' hard labour for having savagely assaulted landlord Henry Mills after being refused service of beer. More civilised times lay ahead and a vestry meeting was held here in March 1893. Both the Durrington Slate Club and the Cricket Club held their annual dinners here into the first decades of the twentieth century.

The Lamb was rebuilt to plans of February 1915 by Whitehead & Whitehead of Chichester. Aligned from north to south along the west-facing frontage was a public bar with taproom behind, a bottle and jug, a central saloon bar and a dining room. During the late 1920s and early 1930s, the local vicar, Revd E. W. D. Penfold, also a sergeant in the Special Constabulary, entertained other members of that Durrington force to an annual dinner at the Lamb Inn. On Boxing Day 1952, the darts team of the Lamb Inn and the Durrington Darts Club revived the local tradition of a comic football match. The players made their way from the inn to the recreation ground accompanied by a band of drums and accordions playing 'Sussex-by-the-Sea', the procession headed by a local garage proprietor in an electrically propelled 1902 car. The game was played in an array of fancy dress and the Durrington Club won 3-1. The football matches continued until 1959 when it was decided to switch to baseball. Stoolball would have been more appropriate as the Clapham & Patching Stoolball Club had held their annual supper here the previous November. Trevor Vaughan and his family ran the inn from 1955 to 1984. The name was changed to the Park View in April 2018 after a refit under new, local landlord, Steve Pease.

Lamb Inn before rebuilding. (Courtesy of West Sussex County Council Library Service, www. westsussexpast.org.uk, PP-WSL-L001019)

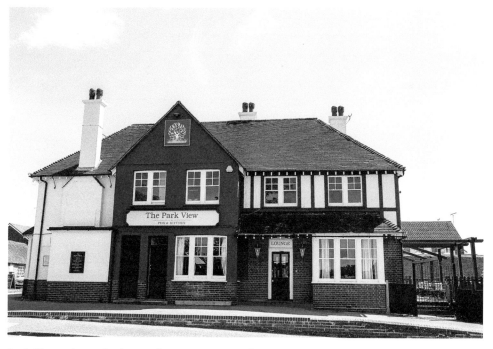

Park View – formerly the Lamb Inn. (Courtesy of Steve Pease)

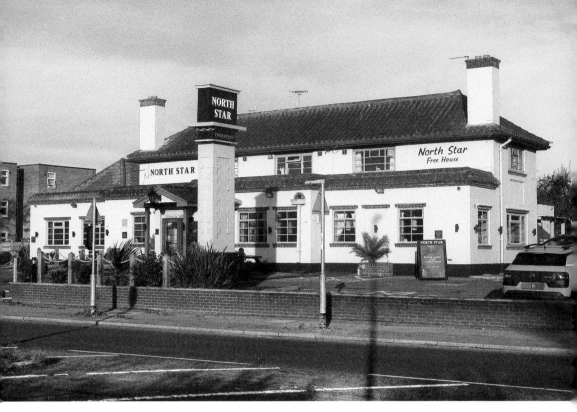

North Star – rebuilt *c.* 1938.

13. North Star, Littlehampton Road (EA-FR)

This was a beerhouse by September 1853 when landlord George Beatty was refused an alehouse licence. Landlord Henry Curd died here on 24 January 1898, aged fifty-one, and was succeeded by his widow, Susan Elizabeth, who gave up the licence in 1907 to her younger brother, George Edwin Willard. In January 1913, an inquest was held here into the sudden death of his wife, Ellen, aged forty. She had expired on a seat near West Tarring Church where she had rested after being caught short of breath on the way to West Worthing railway station. Her death was attributed to asphyxia caused by pleurisy. The inn was rebuilt to plans of November 1937 by Friary, Holroyd & Healy Brewery. These show a public bar at the west, a central off-sales and a saloon bar at the east with private bar behind. A full licence was granted in May 1939 via a transfer from the White Hart at Petworth. The new landlord of 1941, Clifford Wood, was a former golf professional at Wimbledon, Beaconsfield, Maidstone and Worthing courses. He once sold a golf ball to the Duke of Windsor. In July 2012, the pub provided an appropriate meeting place for the Worthing Astronomers stargazing group.

14. Sussex Yeoman, Palatine Road, Durrington (WT)

A provisional licence for a hotel at this site to be called the Winston Churchill was granted to Henty & Constable Brewery in February 1951 but the project was delayed to the extent that their successors, Watney Tamplins, were left to regretfully surrender this licence seven years later. 'With some sense of realism, the brewery feels unable to proceed with the plan', lamented their spokesman. The location continued to hold out promise, for on Wednesday 17 May 1967, Mr Sanders Watney, Chairman of Watney Tamplins brewery, and Colonel John French, formerly

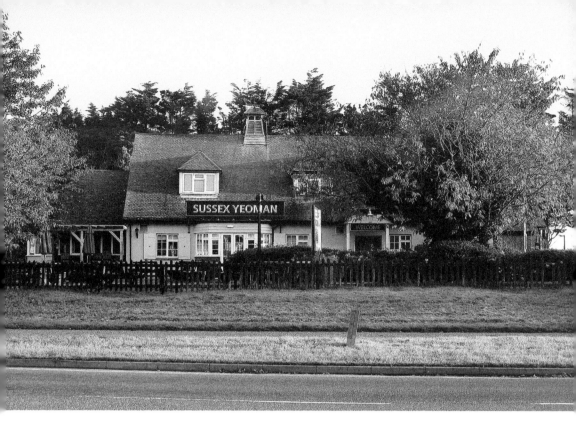

Sussex Yeoman – opened May 1967.

of 257 (Sussex Yeomanry) Field Regiment RA, officially opened this new pub. Designed in the vernacular 'Sussex cottage' style, the premises consisted of a large saloon, the Cockade Bar, and a public Limbrick Bar with darts and bar-billiards. A Boer War period uniform of a colonel of the Sussex Yeomanry formed a showpiece in a display case at the entrance. Landlord Larry Peasland and his wife, Eileen, held a whisky-tasting party to raise money for a children's trust charity in July 1974. Extensive refits have since altered the appearance and transformed the interior of what is now part of the Hungry Horse pub-restaurant chain of the Greene King Brewery of Suffolk.

15. Golden Lion, No. 7 The Strand, Durrington (WH)

A licence for temporary premises, provisionally to be called the Durrington Arms, was granted to Whitbread Brewery in February 1950. A white-painted prefabricated single-storey structure with two gabled bays flanking a central section was then constructed just outside Durrington railway station on the north side of Chesterfield Road. It was officially opened as the Golden Lion at 11.30 a.m. on Wednesday 25 July 1951 under landlord Gustav Adolph Stietencron. Whitbread eventually overcame opposition by the council to erect a permanent pub in its present position and this was opened on Tuesday 23 January 1962 under its subsidiary company the Improved Public House Ltd, the licence having been transferred from the prefabricated pub, which had held its final session the previous evening. An improved pub in the futuristic context of the 1960s meant no spilt beer by way of sloppy hand pulls. Exact measures were instead dispensed into oversized glasses by the touch of a button. Another forward-looking move was to employ the term 'home-sales' department in preference to the traditional 'off-sales'. To the right

of this central home-sales was a public bar, the Arundel Tap, with games recess; to the left was a saloon bar, the Bramber Lounge, with an extension for a club room. It would not be long before even this type of multi-bar interior would be regarded as outmoded and the walls knocked though to create open-plan layouts.

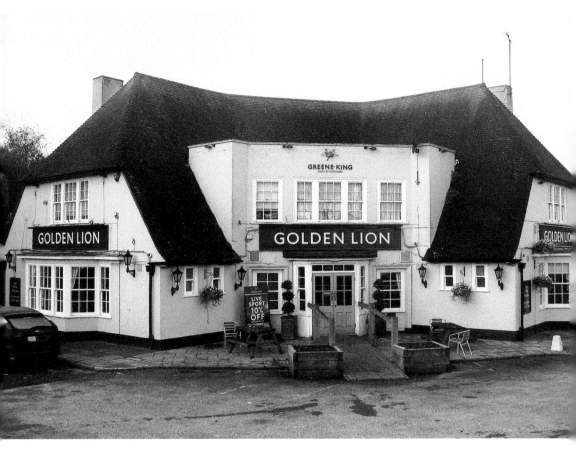

Golden Lion – opened January 1962.

2

Heene, Montague Street and Marine Parade

Fanny Carter and George Knight were beer retailers in Montague Street in 1841 and 1845 respectively. We finish this trail next to West Buildings where, at No. 27, Nigel Watson with Deborah Blakely opened Anchored in Worthing on 23 August 2013 – the first micropub in Worthing and Sussex.

16. British Sportsman, No. 94 Heene Road

The British Sportsman Hotel and Tavern with Tap, pleasure garden and skittle ground was auctioned at the Steyne Hotel on Saturday 13 October 1832. The premises later became Heene Villa, then Heene Lodge. Until the middle of the twentieth century the Sportsman name was still visible in damp weather on the wall above the top windows. A cement and flint cockpit also remained in the garden and there was a bricked-up entrance to a tunnel in the cellars. This 'Regency-style farmhouse' was demolished in August 1962 for the flats that now stand on the site but still bear the name of Heene Lodge.

17. King & Queen, No. 8 Brunswick Road (PS)

This was the former name of the Brunswick Hotel (below) that was transferred to this beershop with the August 1867 application for the change. It closed in April 1900 as a condition for the opening of the Central Hotel.

18. Brunswick & Thorn Café & Bistro, Thorn Road

As the King & Queen Inn, this was known by August 1836. The inhabitants of Little Heene were then regarded as 'lawless', but by the 1867 change of name to the Brunswick Hotel, this was developing into a respectable residential area and a vestry meeting was held at the hotel in August 1872. The Worthing Association Football Club had their first annual dinner here in July 1890, while a dinner was given that December by the Amateur Minstrels to Mr Wakefield,

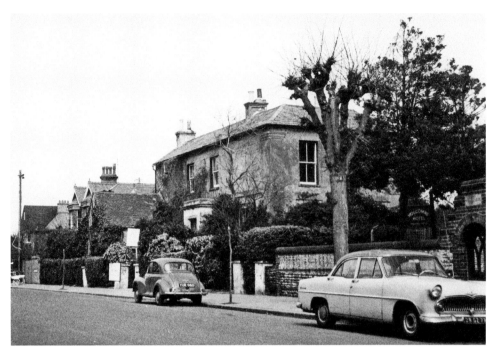

Heene Lodge, 11 April 1962. (Courtesy of West Sussex County Council Library Service, www. westsussexpast.org.uk, WSL-P005393)

King & Queen beerhouse – closed 1900.

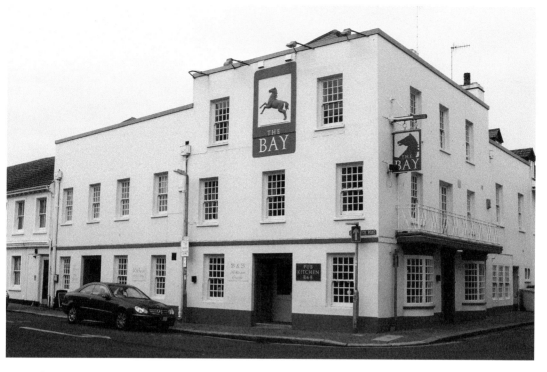

Above: The former Brunswick Hotel – now the Brunswick & Thorn.

Right: 'Pleasantly Situated'. (Kirshaw's Worthing Directory, 1883. Courtesy of West Sussex Record Office)

104 WORTHING DIRECTORY.

BRUNSWICK HOTEL,

WEST WORTHING.

J. H. MARSH, Manager.

This Hotel, which is pleasantly situated, and having Sea Views, has been recently re-furnished and re-decorated, and offers every accommodation to visitors at most reasonable charges.

COFFEE, SMOKING & BILLIARD ROOMS.

Suites of Apartments may be had. Tariff on application to the Manager.

THE "BRUNSWICK"

WINE & SPIRIT STORES

WHOLESALE AND RETAIL.

STORES: THORN TERRACE.

The Proprietors, being shippers, are enabled to place before the residents and visitors, a list of Wines specially selected and of the finest vintages.

BOTTLED ALES & STOUT.

the originator of the troupe and who was departing the town. The annual supper of the Heene bellringers was held in January 1893 and two months later the hotel hosted the resurrection of the Royal Ancient Order of Buffaloes (Worthing No. 1 Lodge). By 1933, this was a far-flung outpost of the William Younger Brewery of Edinburgh.

The Worthing Big-Game Angling Club was formed here in February 1955; their aim was 'to catch the biggest possible fish with the lightest possible tackle'. The landlord was then Bob Smith, who had arrived here when his parents took over in the early 1930s. He had served in the RAF during the Second World War and was a member of both the South Coast Flying Club and Worthing Sailing Club. He retired as licensee in 1968, having founded the local Licensed Victuallers Association. Diana Ball retired in January 2008 after ten years here, having turned it into a popular live music venue. In 2010 it was rebranded as the Aintree Pub & Kitchen and from 2012 to 2014 it was, briefly, the Bay. It reopened in 2018 under its current name.

19. Rose & Crown, Nos 169–173 Montague Street (CO-WG-TA-WT)

Noah Smith Lee was resident here by November 1839. His August 1840 application for an alehouse licence for his beershop was refused, but he was successful eight years later. The house was to remain in his family until 1887 and they were followed by only two more – the Blanns and the Avenells – until the 1940s. This was the headquarters of the Worthing Social Benefit Society in 1902. May 1904 saw a domino tournament of some ninety competitors. The pub whist club ended their season here in April 1907 with a Supper and Smoking Concert, during which their chairman expressed his hope that they would continue to improve their form until they became champions. The dream became reality two seasons later when they won the league by a margin of two points. Wireless listening took place at the pub from 7 p.m. every evening in January 1923 at no charge. The pub reopened in July 1982 after an £80,000 refurbishment in which the former separate lounge and public bars were transformed into the current open-plan interior with its three distinct areas. In 2005, landlord Dave Edwards became embroiled in a dispute with the council planning department. He had for two years flown a European Union flag outside the pub but they had now informed him that it did not constitute a national flag but a form of advertising, for which he was required to pay a charge of £220 unless he took it down.

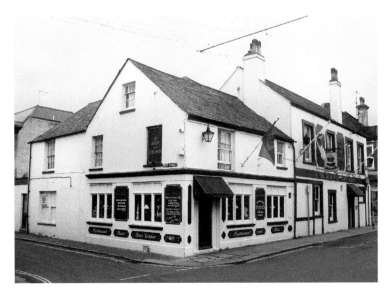

Flying the flag at the Rose & Crown.

20. Prince of Wales, No. 167 Montague Street

Known by 1866 under John Wing, it was possibly tied to the Portslade Brewery who owned the new Southdown Hotel for which this licence was surrendered in October 1894. The magistrates were critical at the time that this mere beerhouse licence was given up for a full one.

Prince of Wales – closed 1894.

21. Rambler Inn, No. 12 West Street (TA)

Known by 1818 under James Wicks, it was reputed to have been a haunt of fishermen and smugglers. A guidebook of 1831 recommended it as a house 'for the less wealthy grade of traveller and sojourners'. Thomas Wicks, landlord for four decades from the 1830s, was also a bath proprietor and bather. The original inn had at some point been struck by a lightning bolt and the marks remained down the side wall until it was demolished and rebuilt in the late nineteenth century. The Worthing & District Ring League had its headquarters here in 1925. The inn closed when its full licence was transferred in February 1929 to the Elms. This was with the consent of landlord Jeremiah William Clark, who was also was a bookmaker, well known at many racecourses. The modern Wyvern Court now occupies the site.

Rambler Inn before rebuilding. (Courtesy of West Sussex County Council Library Service, www. westsussexpast.org.uk, WSL-P006596)

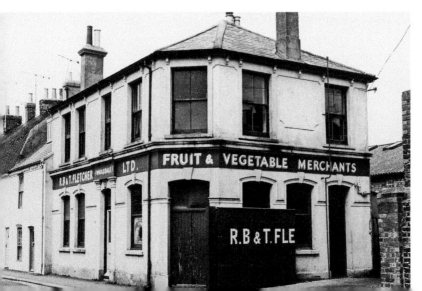

The former Rambler Inn, 4 June 1969. (Courtesy of West Sussex County Council Library Service, www. westsussexpast.org.uk, WSL-P006594)

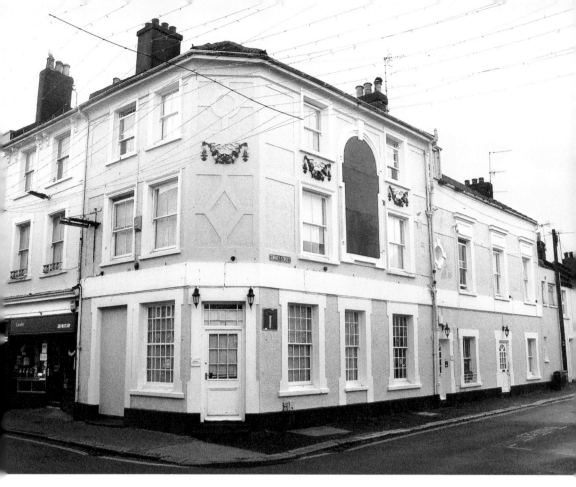

Montague Arms, 1869–2015.

22. Montague Arms Hotel, No. 149 Montague Street (KTB-CH)

A new licence for this house was granted to Harry Holden in August 1869. The Thurston Table billiard room of 1890 was advertised as one of the most commodious and best ventilated in town. For most of the twentieth century the pub was run by just two families – the Howells followed by the Chapmans. Local shove ha'penny league members voted 20-16 against a ban on women players during a September 1950 meeting here. The motion that teams should consist specifically of nine *male* players was made by Mr Phillips of the Montague Arms and Mr Greenyer of the Cobden Arms. 'Where are all my women haters?' goaded the latter as the count was taken. The local British Legion branch held their meetings here in the mid-1950s. In a September 1956 'pushing-over ceremony', the mayor, Councillor Osland, climbed atop the bar counter to send a 5-foot 2-inch, 1.5-cwt column of coppers tumbling. The £32 worth of pennies, which had been dipped in beer and arranged around a pint glass in circles of eight, were in aid of the new Maybridge Boys Club. Worthing's newest restaurant opened upstairs here in 1984 when the pub advertised itself as having 'no juke boxes to put up with!' The pub had twice closed and reopened prior to its 2015 conversion into offices, with the licence expiring on 12 November that year.

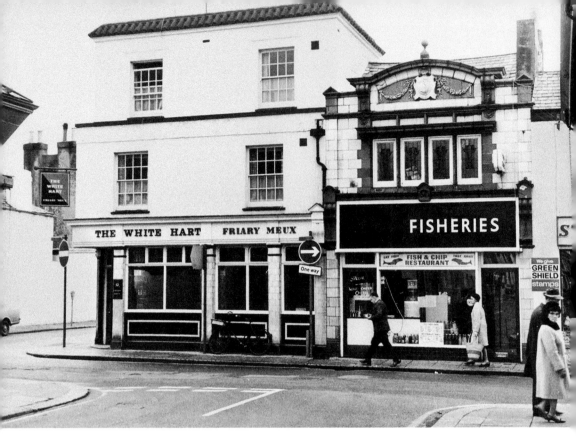

White Hart, 27 November 1968. (Courtesy of West Sussex County Council Library Service, www.westsussexpast.org.uk, WSL-P006198)

23. White Hart, No. 121 Montague Street (EA-FR)

James Penfold was granted an alehouse licence for this beerhouse in August 1838, which he formally opened as fully licensed premises on 10 October that year. The evening of 4 January 1839 was appointed for the meeting there of his friends and patrons, who proceeded to test the merits of the various beverages the house afforded. Felix Cooper, landlord here for thirty years from the mid-1850s, was also a fly-proprietor. A third storey was added at the north to plans passed in June 1937. The pub advertised itself colloquially as Jimmie's in the early 1950s, when a children's party room was open at Christmas and a Rum, Punch & Gala Night was held on New Year's Eve. The landlord of the mid-1950s, Eric Percy Hinton was a keen fisherman who would spend the early mornings out on his boat, Mizpah. He would give away his daily haul of plaice over the bar to his customers, but it took him twenty minutes to land his biggest catch – a 5-foot, 40-pound tope. The last ever session at the White Hart was held on the evening of Saturday 16 March 1985. The Sompting Morris Men had danced outside on the final lunchtime. The pub was subsequently demolished for the modern retail units that now occupy the site.

24. New Street Inn, Nos 13–15 New Street (WT)

The New Street Brewery was open by 1845 under William Clark. George Pacy arrived here from Bognor in 1863 and ran it until his death in 1903, after which his son, George Jr, took over. The attached beerhouse had become colloquially known as Pacy's Bloodhole because the local fishermen would gut and clean their catch there. The brewery was rebuilt to plans of January 1910 by R. W. Andres of London. When George Jr died in 1931 he was succeeded by

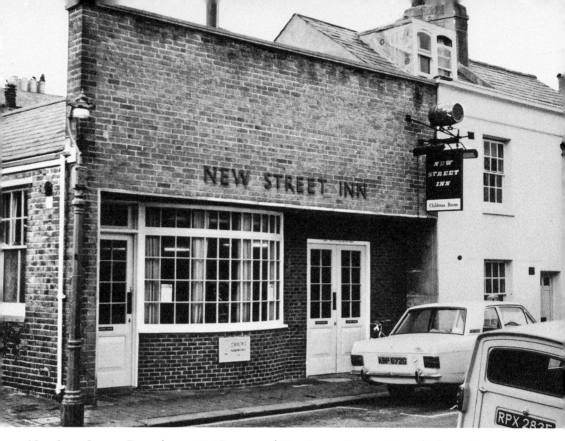

New Street Inn, 19 December 1968. (Courtesy of West Sussex County Council Library Service, www.westsussexpast.org.uk, WSL-P005883)

his son Sydney until June 1938 when on-site brewing ceased and the premises were purchased at auction by Hammertons Brewery of London, who were themselves acquired by Watney, Combe, Reid in 1951. A wine licence had been granted in February 1943 and a full licence was secured in February 1952 along with a change of name from the New Street Brewery to the New Street Inn. A new brickwork façade was erected in 1953 and the 70-foot brewery chimney was demolished the following year. The defunct brewery rooms were then the headquarters of the Over 21 Club, the West Sussex Wheelers cyclists and the social club of the South-Eastern gas board. The inn was renamed the Beachcomber in 1979. At 11 a.m. on Thursday 2 May 1991, it was formally reopened under the name A Town's Pride, after the Rob Blann book of that title on local lifeboat men. The pub closed either in or shortly before April 2003 to reopen as a restaurant.

25. Augusta Arms, Augusta Place
Known by 1870, trade at this beerhouse was reported to have been 'extremely meagre' and it did not last beyond 1882. It stood to the rear of the Montague Street premises of baker George Heasman, who purchased it and converted it to a flour store.

26. Buckingham Arms, No. 80 Montague Street (TA-WT)
This was known by 1835 under landlord Richard Bacon. In August 1897, harvester Martha Bassett was fined 2s 6d for being drunk and refusing to quit the premises, despite her expressed hope that the gentlemen of the court would let her off because she had two children to support.

Buckingham Arms – closed January 1987.

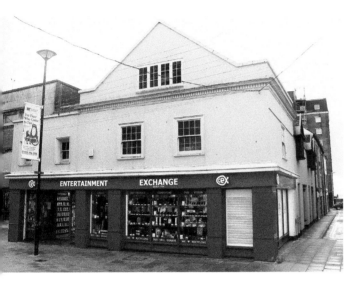

Victoria Inn – closed April 1982.

In October 1906, Ike Shawcroft used his payment from performing at the local theatre to become drunk and disorderly here. 'That's me!' declaimed the accused actor as the charge was announced in court. On Sunday evening of 9 June 1940, Evelyn Bertha Newman, wife of the landlord, was serving behind the bar when she was suddenly taken ill. She died in hospital in the early hours of Monday, aged just forty-seven. The final ever pint at the pub was pulled on 31 January 1987 under licensee John Alan Smith. This Grade II listed building with striking M-form roof has a post-1982 but perfectly matching ground-floor eastern extension.

27. Victoria Inn, No. 103 Montague Street (TO-KTB-CH)

This was a shop in 1867 and the Victoria Arms beerhouse by 1870. Landlord Edward Street was up before the bench in 1924 for failing to record the details of a foreign guest at the house – then a breach of the Alien Order Act. A wine licence was granted in February 1952 to Arthur Percy Barber. He received a full licence a year later and the brewers were granted permission to formally change the name suffix from Arms to Inn. The pub was declared redundant by Charrington Brewery and closed for the final time on the evening of Wednesday 21 April 1982. The last landlord was Roger Merritt, a former Metropolitan policeman.

28. Kings Arms, No. 99 Montague Street (TA-CO-WG-FR)

An alehouse licence for this beerhouse was granted to Richard Marley in August 1835. The following November he had a hundred herrings stolen from a coach house behind the pub. The Ancient Order of Foresters (Court 'Pride of Worthing', No. 4,187) had its headquarters here in 1891 and in 1895 it was home to the Star Cycling Club. By June 1939 the old house had been completely rebuilt in three storeys of red brick with a prominent Flemish gable at both front and rear. The ground floor contained a public bar, smoking room, children's room and a lounge. The general contractors were local firm Frank Sandell & Sons and the architects were Godman & Kay of Horsham. It is a shame that such a strikingly designed public house lasted just twenty-six years. It closed for the final time on Monday 7 June 1965 and was demolished by December of that year. Modern retail units now occupy the site.

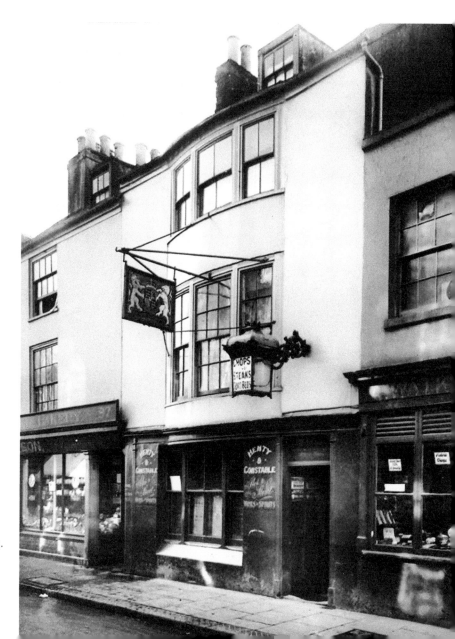

Kings Arms
before rebuilding.
(Courtesy of
Jack Regis)

The Landlords

Thomas Brackley and his family arrived here from Steyning *c.* 1874 and he became the landlord of the Selden Arms from *c.* 1882–95. His youngest son, Edward Anscombe, took the Kings Arms in 1899 and moved after ten years to become the first landlord of the Thomas á Becket. Edward went to the White Hart in 1913 and remained there until he became Mayor of Worthing in 1939–40, with the licence leaving the family two years before his death in 1943. Edward had been followed at the Kings Arms, briefly by his father, then his mother, until 1912 when his brother, Henry Jeffrey, became the landlord. Henry died in 1932 and his wife Annie took over until her retirement four years later. Their son, Henry Jeffrey Thomas, then took the licence and remained here until 1953 with the exception of war service with the Home Guard when his wife, Violet, ran the pub. Jeff, as he was known, became Mayor of Worthing in 1954–55 and died in 1979.

29. Montague Brewery Inn, No. 62 Montague Street

The Montague Brewery was in operation by 1845 under beer retailer Edmund Lephard. Brewing ceased on site in October 1889 when the plant was sold and the beerhouse became an agency for the Eagle Brewery of Arundel. Two long-serving occupants were Jacob Searle, here from 1862 to 1888, and Thomas Macdonald Cornford, who from 1893 to 1914 was retailing beer in conjunction with his pork butcher business next door at No. 64. The beerhouse was sold and closed by February 1921; the licence expired on 5 April of that year and the premises became shops. The lettering 'Montague Brewery, Lambert & Norris' was faintly discernable on the pediment prior to its 1969 demolition. Modern retail units now occupy the site.

The former Montague Brewery Inn, 27 November 1968. (Courtesy of West Sussex County Council Library Service, www.westsussexpast.org.uk, WSL-P006195)

30. Running Horse Inn, No. 21 Paragon Street (WS-TA-WT)

This was open as a beerhouse by 1832 under Edward Stilwell who three years later was granted an alehouse licence. It was then known, variously, as the Fisherman, Jolly Fisherman and Fisherman's Arms. The swift equine name had been bestowed by New Year's Day 1839 when the annual meeting of a benefit club was held here. Henry Finnis had been the landlord for thirty-one years when he died aged seventy-one in October 1911. He had joined the merchant navy as a boy aged twelve, eventually attaining the rank of captain. His voyages of more than a quarter of a century had taken him round the Cape Horn to Valparaiso and as far east as India. He was succeeded to the licence by his son, Henry Thomas, whose sudden death from pneumonia, aged thirty-five, occurred in June 1914. On 1 October 1934, barmaid Daisy Conyers D'Arcy served two drunken men for which she was subsequently fined £1 with £4, 3s costs, as too was landlord Thomas Macdonald Cornford despite him not being present at the time. The landlord of 1945, Archie Medhurst, was a former all-round athlete and open lawn tennis player who now preferred the gentler game of bowls. He purchased and saved for local use the Manor House Country Club on the Field Place estate. The inn was of three storeys with three entrance doors and a late 1930s tiled ground floor frontage when it was closed with the January 1962 purchase of the site for a new Tesco supermarket. The demolition of the whole of Paragon Street was in progress by June of that year.

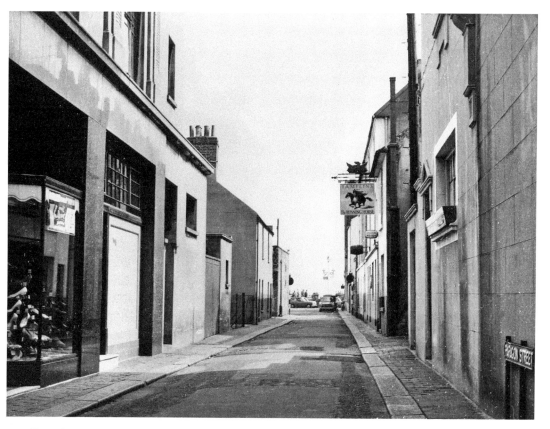

Running Horse, 1960. (Courtesy of West Sussex County Council Library Service, www. westsussexpast.org.uk, PP-WSL-P005940)

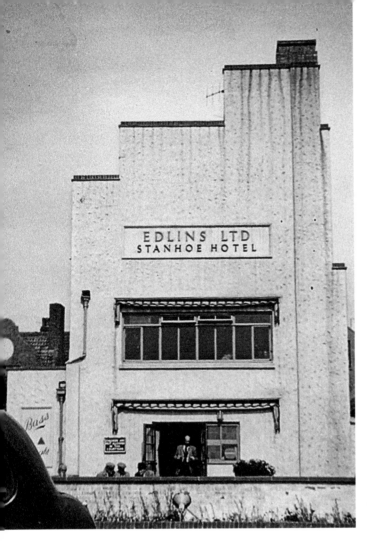

Edlins Stanhoe Hotel, 1950s.
(Courtesy of Clive Purser)

31. Edlins Stanhoe Hotel, Nos 64–65 Marine Parade

Originally Trafalgar House, it was renamed Augusta House after the stay there by Princess Augusta in 1829–30. It became the Stanhoe Hall Hotel after a May 1893 refurbishment, with the middle name dropped c. 1903. New purchasers of 1939, Edlins Ltd had begun in August of that year to clear the site for a new public house that was to be the biggest in the town, but the Second World War swiftly curtailed the proceedings. Although temporary licensed premises were erected, the remains of the old Regency building, which had become derelict and blast-damaged, were not demolished until 1948. A car park took its place and a functional structure set further back from the site was erected to plans of December 1950. It closed for the final time on 31 December 1965 and was eventually demolished for the Grafton redevelopment.

32. Parade Wine Lodge, No. 82 Marine Parade

Opened on 15 June 1950, it was probably the first new permanently built licensed premises, specifically with a new excise licence, to do so in the country since the Second World War. Most pubs then had a brewery-restricted range of beers and did not cater for food; hence, with its well-stocked bar (said to be the longest in the south), restaurant, tearoom and separate rear children's room, this was announced as 'the public house of the future'. The owners were

Roberts & Son, the local firm of wine merchants, and a striking feature of the interior was a series of seven mural oil paintings by local artist Peggy Labram, conveying the creation of wine from the planting of the vine to the savouring of the matured product. Designed by Lawrence A. Cooper & P. Winton-Lewis of London, the new 'building of Mexican style' incorporated the early Victorian Parade Lodge, once the house of Thomas Banting and which, after his death, he bequeathed to become a convalescent home in memorial of his name. The Wine Lodge was acquired *c*. 1979 by Courage Brewery who found it unprofitable and sold it in 1984 to the Alexandra Brewery of Portslade, who later put in plans for its demolition. It was saved through a Chris Chapman buyout of 1986 but was sold in November 1987 to First Leisure, the owners of Blackpool Tower. On 14 December 1995, it officially opened as the Litten Tree – part of the national chain of that name and a popular live music venue. It closed for the final time on 31 December 2001 and was demolished the following year for the Regency-style Nautilus terrace that now occupies the site.

Litten Tree – originally the Parade Wine Lodge. (Courtesy of West Sussex County Council Library Service, www. westsussexpast.org.uk, Paul Holden Collection)

Parade Wine Lodge interior, 1978. (Courtesy of Dick Pike)

3

Portland Road to Worthing Railway Station

Until 1898, Portland Road was called Chapel Street. John Allen was a beer retailer there in 1845, possibly at what was then No. 23 where in 1851 he is a carpenter. Henry Bennett, a porter by trade, was a beer retailer in 1862 at what was then No. 20. North-west of Worthing railway station at No. 38 South Farm Road, the Brooksteed Alehouse micropub was opened by Nick and Paula Little on 5 September 2014. Aaron Burns and his partner John Azzopardi became the new proprietors in April 2017.

33. Spaniard Hotel, No. 25 Portland Road (CO-WG-FR)

A December 1811 auction notice stated this inn to be in the hands of Mr Tuff and to have been 'built about three years ago'. Mr Tuff died the following February and his funeral cortège was attended by a grand procession of Freemasons. Richard Kent Payne became proprietor in October 1847 and one year later hung himself in the adjoining stable. A verdict of suicide during temporary insanity was reached after it was discovered that he was in expectation of, but had not received, a much-needed sum of money. Landlady Mrs Maria Bicknell was brewing on the premises during 1857–64. William Henry Mates had been proprietor for six years when his career in the licensed trade was ended in 1890 by a prison sentence of eight months – in an action quite out of character, he had stolen the contents of a cash box at the Pier Hotel. He was succeeded here by Edward Tettersell, a descendant of Captain Nicholas Tettersell of the Old Ship Hotel, Brighton, in whose boat Charles II escaped to France in 1651. Edward Tettersell died in 1901, aged thirty-nine, and his wife, Frances, carried on for another twenty-eight years. In 1938, the building was transformed by Patching & Co. to a neo-Tudor design by Godman & Kay of Horsham and the new-look hotel was formally opened at 6 p.m. on Friday 16 December that year. It had three bars: an oak-panelled saloon lounge, a tapestry-hung saloon bar and a public bar. By 1959, under Ron and Peggy Brewer, it had a Spanish Armada Grill Room. The public bar was converted to a wine shop c. 1961. The pub closed for the final time on 31 December 1979 and the building was subsequently demolished. The rear of Boots store now occupies the site.

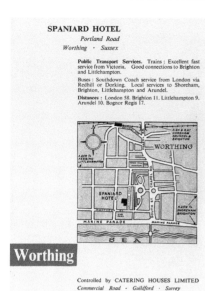

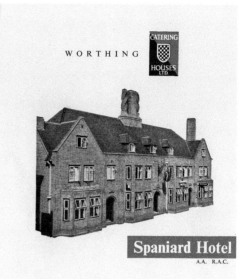

SPANIARD HOTEL
Portland Road
Worthing · Sussex

Public Transport Services. Trains : Excellent fast service from Victoria. Good connections to Brighton and Littlehampton.

Buses : Southdown Coach service from London via Redhill or Dorking. Local services to Shoreham, Brighton, Littlehampton and Arundel.

Distances : London 58. Brighton 11. Littlehampton 9. Arundel 10. Bognor Regis 17.

Controlled by CATERING HOUSES LIMITED
Commercial Road · Guildford · Surrey

A Subsidiary Company of Friary Meux Ltd.

WORTHING

Spaniard Hotel
A.A. R.A.C.

TELEPHONE · WORTHING 395

Spaniard Hotel brochure cover. (Courtesy of Leigh & Richard Lawson)

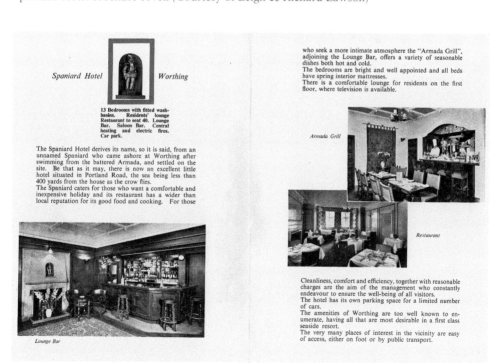

Spaniard Hotel *Worthing*

13 Bedrooms with fitted wash-basins. Residents' lounge Restaurant to seat 40. Lounge Bar. Saloon Bar. Central heating and electric fires. Car park.

The Spaniard Hotel derives its name, so it is said, from an unnamed Spaniard who came ashore at Worthing after swimming from the battered Armada, and settled on the site. Be that as it may, there is now an excellent little hotel situated in Portland Road, the sea being less than 400 yards from the house as the crow flies.

The Spaniard caters for those who want a comfortable and inexpensive holiday and its restaurant has a wider than local reputation for its good food and cooking. For those who seek a more intimate atmosphere the "Armada Grill", adjoining the Lounge Bar, offers a variety of seasonable dishes both hot and cold.

The bedrooms are bright and well appointed and all beds have spring interior mattresses.

There is a comfortable lounge for residents on the first floor, where television is available.

Armada Grill

Restaurant

Cleanliness, comfort and efficiency, together with reasonable charges are the aim of the management who constantly endeavour to ensure the well-being of all visitors.

The hotel has its own parking space for a limited number of cars.

The amenities of Worthing are too well known to enumerate, having all that are most desirable in a first class seaside resort.

The very many places of interest in the vicinity are easy of access, either on foot or by public transport.

Lounge Bar

Spaniard Hotel brochure inside pages. (Courtesy of Leigh & Richard Lawson)

SPANIARD INN,

CHAPEL STREET, WORTHING,

(Within a short distance from the Sea)

MARIA BICKNELL,

Wine and Spirit Merchant,

Begs to assure parties visiting Worthing that her House will be found to possess every comfort and convenience; and also to thank the public and her friends for past favours, hoping by moderate charges and attention to their comfort, to ensure their continued support.

———o———

GOOD STABLING AND LOCK-UP COACH HOUSES.

Spaniard Inn. (French & Watkis's Handbook & Directory for Worthing, 1857. Courtesy of West Sussex County Council Library Service, www.westsussexpast.org.uk)

34. Albion Hotel, Portland Road (WH, BR)

Thomas Russell was the son of the first postman in Worthing. He was a retail brewer here by 1849 and was granted a licence in August 1852 for this commercial inn. The engineering of the adjacent Albion Steam Brewery was undertaken by Jim Jackson, a former train driver who brought the first ever locomotive into Sussex. The brewery became redundant after Leonard Hunter took over in 1873. There was a Shades Bar in Field Row by 1892. The Excelsior Cycling & Athletics Club were having their annual dinner here in November 1907 when the presiding mayor heard that the Star Cricket Club were at that moment partaking of their annual dinner at the Railway Hotel. He immediately put through a greeting to them by telephone, wishing them every success in their sport, and promptly received a similar message of congratulations through the same medium. The hotel was run by Jesse Howell from 1919 until his death in 1932. The building was modernised for Whitbread Brewery to plans by Godman & Kay of Horsham, passed in July 1933. The new house had a public bar that fronted onto Montague Street, to the north of which was a smoke room and a saloon lounge. A café lounge was next to the entrance hall on Portland Road, where there was a forecourt for cars and a large rear garage. Jim Clark was the manager when the licence was surrendered by Brickwoods Brewery on 30 June 1962. The building was subsequently demolished and a Superdrug store now occupies the site.

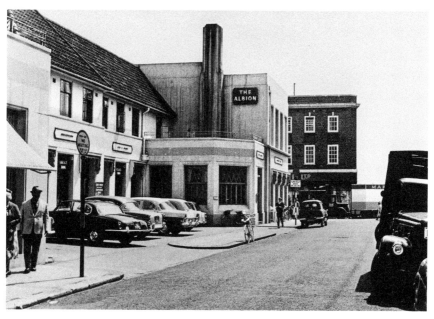

Albion, 22 June 1962. (Courtesy of West Sussex County Council Library Service, www.westsussexpast.org.uk, WSL-P005986)

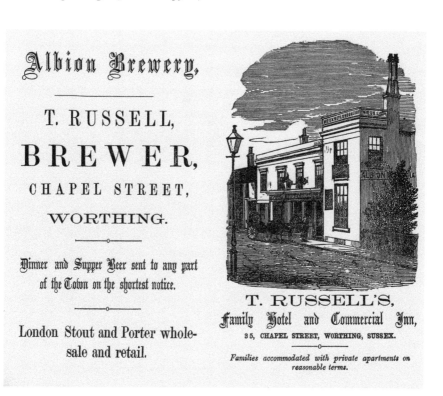

Albion Hotel and Brewery. (French & Watkis's Handbook & Directory for Worthing, 1857. Courtesy of West Sussex County Council Library Service, www.westsussexpast.org.uk)

35. Feathers Inn, No. 53 Portland Road (TO-KTB)

Open by 1866 under James Rulf, this was also known as the Prince of Wales, the Prince of Wales Feathers, and the Ostrich; the latter name was colloquial and referred to the three ostrich plumes of the sign. A common lodging house then at the rear was used by vagrants. In the early morning of 1 February 1923, landlord Frederick Bowman, who sidelined as a commercial traveller of cigars, was found dying on Hampstead Heath having drunk two bottles of oxalic acid. He had become depressed over a lack of trade and a verdict of suicide while temporarily insane was given at the inquest. His wife afterwards ran the premises as a dining room until its closure in 1926 when the licence was transferred to the newly built Ham Hotel. The narrow, three-storey terraced building was demolished in November 1960. The north end of Mānuka Bar & Kitchen and its adjoining passage now occupies the site.

36. Hare & Hounds, Nos 79–81 Portland Road (PBU-BR-WH)

The pre-1814, flint-faced No. 81 was a beershop by 1851 under William Read. From *c.* 1858 until his death in 1875 it was run by Moses Bodle. He was succeeded by his son, John, who died four years later. The licence then passed to John's widow, Charlotte, who carried on until her death in 1909, after which their son, George, took charge until 1914. The next landlord was riding master and keen huntsman Charles 'Charley' Jesse Pollington, who was here until his death in 1946. The Hare & Hounds was then just a small beerhouse with a tiny snug bar or parlour – there was only just enough room for the door to open into it. This changed in May 1974 with the commencement of a modernising and southward extension of the premises into

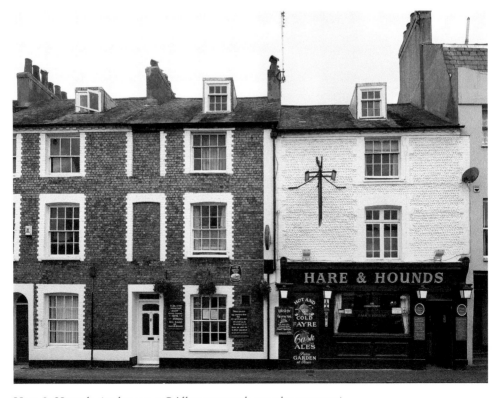

Hare & Hounds. (cc-by-sa2.0-©Allan-geograph.org.ukp4711930)

No. 79. The hosts at the time were Sam and Nellie Brookes. They had been here since 1955 and Sam had acquired a full licence in February 1959. The drinking area was doubled to its present size by a rear extension completed in March 1994.

37. Wheatsheaf, Nos 22–24 Richmond Road (TO-KTB-CH)

John Levett was granted an alehouse licence for this beerhouse in August 1838 after his retirement as the town crier and senior beadle. A former sergeant-major in the Dragoon Guards, Levett had fought on the battlefield at Waterloo where his camp-follower wife, Ann, had tended

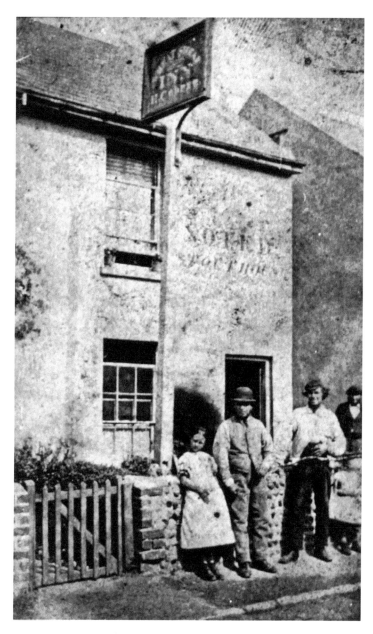

Wheatsheaf before rebuilding. (Courtesy of West Sussex County Council Library Service, www. westsussexpast.org.uk, PP-WSL-No57918)

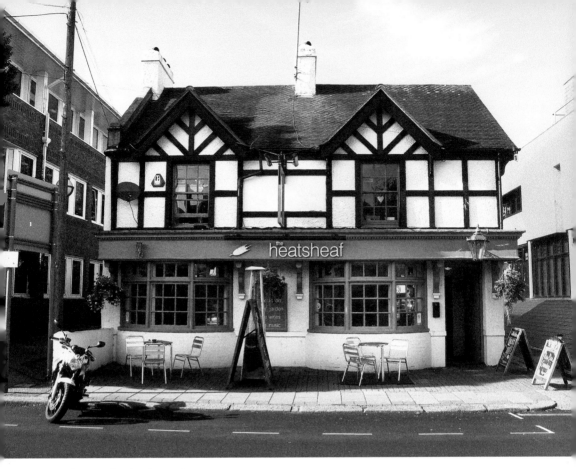

The heatsheaf – dropped W.

to the wounded. The 125 gold sovereigns found hidden at his house after his death in February 1850 were possibly Napoleonic War booty. Long-serving landlord Henry Cooper retired from here in 1902 after forty years behind the bar. The pub was rebuilt to plans by F. J. Cawthorn, approved in June 1925. These show a public bar at the west and a private bar at the east with a bottle and jug and saloon bar behind. In 1935, Archibald Leonard Streeter, the eldest son of the landlord, became the first Worthing man to pass through Kneller Hall, the Royal Military School of Music. He went onto become Director of Music to the Canadian army in August 1939. The pub was popular with the local pressmen in 1945. Bert Thomas, the new pipe-smoking landlord of 1954 was a Freeman of the City of London and former member of Dulwich Hamlet Football Club. Eric Brown took over from him in 1966 and thirteen years later was fortunate to escape, along with his wife Sybil and her eighty-one-year-old mother, Gladys, from the first floor after an electric fault caused a serious fire. The pub had a more recent chequered history before its final licence expiry on 29 March 2017. The building currently stands shut and boarded.

38. Richard Cobden, No. 2 Cobden Road (BL-RO-PBU-BR-WH)

A new licence was granted in August 1869 to Mr Lewry for the Cobden Arms. In May 1910 a bolt of lightning collapsed the chimney stack, scattering its bricks though the roof of the kitchen and the scullery; landlord Fred Tupper was fortunate to have been in the bar at the time. The

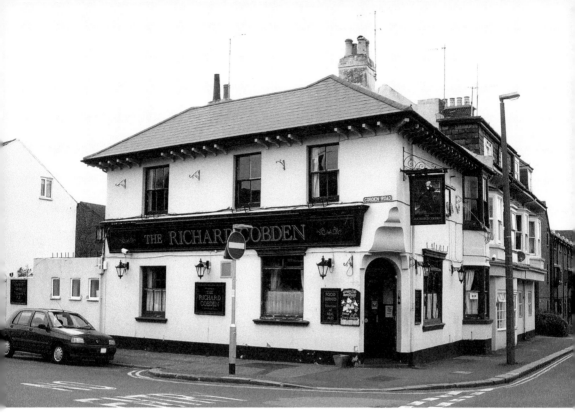

Richard Cobden – originally the Cobden Arms.

pub had a Tontine Club in the 1930s and was a member of a shove ha'penny league in the 1950s. There was until 1952 a separate games room at the west along Cobden Road, but this was afterwards absorbed into the public bar where the old Rock Ales etched window remains. A saloon bar was then at the north corner with a private bar at the centre. The name adjustment occurred *c*. 1987. Richard Cobden (1804–65) was a radical and liberal political activist who was born in Heyshott, near Midhurst.

39. Jolly Brewers, Nos 39–41 Clifton Road (KTB-CH)

An alehouse licence was granted in August 1835 to William Knowles for the Brewers Arms beerhouse at what was then No. 9 New Town. The Jolly Brewers name was in use by March 1856. A tontine society founded here had to meet elsewhere from 1896 as its membership had grown to eighty-four – too large a number to be accommodated at the pub. From 1858 until 1922 the house was in the hands of the Gravett family of brewers and maltsters. It was afterwards acquired by the Kemp Town Brewery of Brighton, who modernised it to plans by Denman & Son of July 1927. These show a private bar at the south, a central bottle and jug, a public bar at the north and a club room at the north-west. From the 1940s to the 1980s the pub was run, first, by Reginald Leslie Streeter (the youngest son of former Wheatsheaf Inn landlord Archibald Arthur Streeter) then his widow Ivy, and finally her son-in-law and his wife, Fred and Betty Hazelgrove. In the early 1980s, this was a tied house of the King & Barnes Brewery of Horsham. The Jolly Brewers sadly shut its doors for the final time in May 2014 and was demolished in December of that year. The site is now part of Heene Primary School.

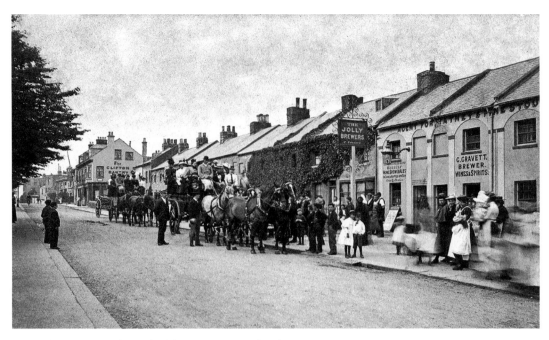

Jolly Brewers before rebuilding. (Courtesy of Jack Regis)

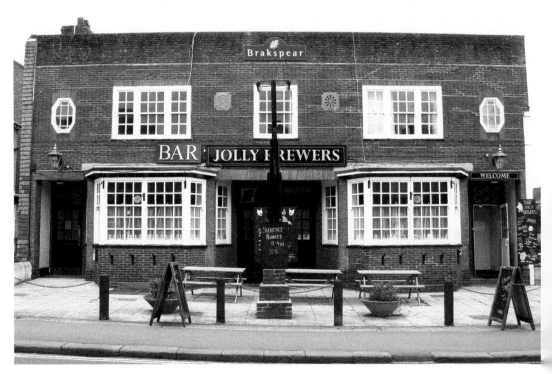

Jolly Brewers, 17 April 2013.

The Local Brewers

Horsham maltster Thomas Gravett arrived at the Jolly Brewers in 1858 and on his death a decade later was succeeded by his widow, Rebecca. She died in 1887 and their son Matthew took over until his death four years later. The licence passed the following year to his own son, George, who remained as brewer and owner for thirty years until his retirement. A word must be said about his Uncle Joshua, who had turned his back on the family business for a very different calling. Having trained as a carpenter, Joshua chose to emigrate to the United States where he became pastor to the Galilee Baptist Church in Denver, Colorado, achieving naturalised US citizenship in 1912 and dying there in 1956, aged ninety-two. On his jubilee of July 1941 his brethren feted him as 'the brewer's son whom the truth made free'.

40. Clifton Arms, Nos 137–139 Clifton Road (PO-KTB-CH)

A licence was granted in August 1867 to Henry Crunden for this house, which was remodelled in Queen Anne style *c*. 1894–95. On 3 October 1900, landlord Anthony David (Dave) Brazier was killed in a tragic accident while rabbit hunting on the downs above Portslade with his brother George and father David. Dave had been lying down by a rabbit hole and suddenly stood up at the same time as his father took a shot at a rabbit. The funeral was attended by around 2,000 people. Landlord Charles Ernest Lodge died in November 1946, aged fifty-six. In the First World War he was wounded and captured at the Battle of Loos of 1915 and spent two years in Germany as a prisoner of war before being repatriated to Switzerland to work with the American Legation. He returned to Worthing after the Armistice and began to serve at the Clifton Arms, taking the licence in July 1925. The pub had then been extended at the west (to plans dated March 1923) to provide a saloon bar and bottle department.

Internal alterations of 1959 gave landlord Frank 'Nobby' Clarke an opportunity to secrete there a record of the times for posterity. On Valentine's Day of that year he asked his regulars, the contractors, staff and family to sign the back of a Charrington Brewery poster. On a second scroll he wrote a miscellany including the prices of commodities, television trivia and local football club performances. Adding a photograph of himself behind the bar and a copy of the newspaper that had carried the story of his idea, he had them rolled up and bound in a bag that was sealed in the stud wall of a new kitchen. The pub closed in 2010 and was eventually converted to residential and retail use. This prompted Paul Holden of the *Worthing Journal* to recall having read in the newspaper archives the 1959 article that had covered the time-capsule story. Paul visited the site to tip-off the builder who, in early 2012, uncovered the package. Paul with Jimmy and Colin of www.worthingpubs.com subsequently gathered for a grand opening in the town library.

The Landords

Son of a Trinity pilot, Southwick-born David Brazier (1840–1915) was an oyster merchant before taking the Stags Head in Portslade. He moved with his wife Kate to become landlord of the Clifton Arms in 1888 and the licence remained in the family for thirty years. In 1886, their daughter Kate Beatrice (1866–1943) married John Pelling Goodwin, who from 1905 to 1913 was landlord of the Norfolk Arms. In 1893, another daughter, Minnie Eugene (1869–1962) married Horace William Symonds, who became landlord of the Southdown Hotel from 1895 before moving to the Central Hotel in 1900 and then the Alexandra Hotel from 1901 to 1917. David and Kate's youngest son, Henry Percy (1886–1954), was landlord of the Clifton Arms for around a decade from 1908 before moving to the Central Hotel where he remained until 1925.

Clifton Arms – closed.

Their oldest son, George Thomas (1866–1945), had been landlord at the Globe from *c.* 1890–1902, when he was succeeded by Benjamin and Alberta Margaret (née Brazier) Dickinson, the latter being David's cousin. George subsequently moved to the Southdown Hotel and then to Clifton Arms from *c.* 1907–09. George's son, Thomas David (1890–1968) ran the Jolly Brewers from 1922 to 1939.

41. Southdown Hotel, No. 38 Northcourt Road (PO-KTB-SM-TA-WT)

This new hotel opened in November 1895 to serve the developing suburban Westcourt estate. The architecturally rich terracotta design was by Samuel Denman and the first landlord was Horace William Symonds. It became the headquarters of a quoits league in 1905. A billiard room was at the north side from 1920 until 1936 when a larger saloon bar was created there, while the ground floor was also expanded to the west that year into a former store and yard. The local branch of the Old Contemptibles Association had their headquarters here in the 1930s, as did the Far Eastern Prisoners of War Association in the 1950s. September 1952 saw the retirement of the town's then oldest licensee Richard Sawyer, here since 1919. Fridays were Country & Western nights here in 1979. The licence expired on 14 November 2016 and the building stands shuttered, with an application made for conversion to residential use. A past signboard had depicted the Southdown breed of sheep on the South Downs.

Southdown –
named after
a sheep?

42. Grand Victorian Hotel, No. 27 Railway Approach (PO-KTB-CH)

Built by Patching & Co. to an ornate design by Samuel Denman, this opened as the Central Hotel on Wednesday 11 April 1900 under landlord Horace William Symonds. The council of the Sussex County Football Association promptly made it their meeting place and were followed by Worthing Football Club and the management committee of the Worthing & District Football League. The Worthing Rotary Club was formed here in 1922. Landlord Brian Downs arrived in 1969 and began the popular 'Faggot and Peas' nights with drag artistes. Regular performers George Logan and Patrick Fyffe went onto become famous as Dr Evadne Hinge and Dame Hilda Bracket. In 1983 this became a free house as Chapmans Hotel and the inaugural meeting of the Arun & Adur branch of CAMRA took place here in March 1988. The hotel reopened under its present name on 9 March 2000. The building is Grade II listed and has a CAMRA historic pub interior of some regional importance through the survival of original fittings such as the five-bay mahogany bar-back and a three-bay partition.

The Landlords

A former petty officer who had served in the First World War, Frederick John Chapman, arrived with his family from Portsmouth to become landlord of the Montague Arms in April 1927. His son of the same name, but known to all as Sammy, was an amateur wrestler who reached the third round of the 1939 National Championship. Sammy served as a petty officer in the Second World War on three ships, all of which were sunk under him by enemy action. He married Mrs Joyce Broad in December 1944 while on survivor's leave and the couple went onto run the Montague Arms. Sammy was Mayor of Worthing in 1969–70. He died in 1975 aged fifty-seven and his son, Chris, who had been born upstairs at the pub, went on to become the licensee. Chris, with his wife Delia, then acquired the Central Hotel, reopening it in June 1983 as Chapmans Hotel. They sold it in September 1995 to Morland Brewery of Abingdon, Oxfordshire. The couple had also embarked on several other local ventures including the Parade Wine Lodge and Café Central. Chris died in May 2019 aged sixty-five.

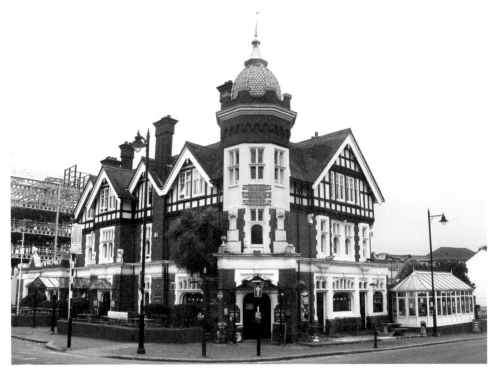

Grand Victorian Hotel – originally the Central Hotel.

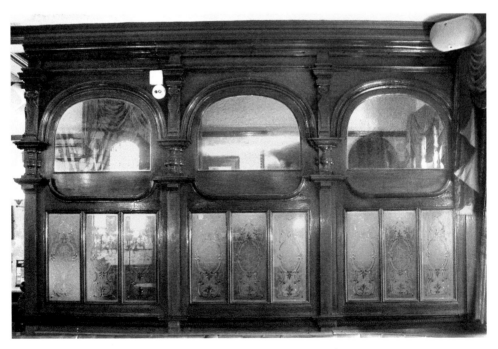

Original fittings in the Grand Victorian Hotel.

<p style="text-align:center">4</p>

Brighton Road to Chapel Road

Charles Russell was a beer retailer in Brighton Road *c.* 1882–87. The Old Bike Store opened at No. 65 Brighton Road on 1 November 2018. Is it a micropub? It is apparently for the punters to decide, and it gets our vote. The Francis Beck listed as a beer retailer in Ann Street in 1866 was possibly Frances Beck, former landlady of the Wellington Inn. Mrs Elizabeth Goodard was a beer retailer in Market Street in 1845.

43. Cow & Oak, No. 67 Brighton Road (TA-WT)

This was the Royal Oak by August 1836 but was formerly the Travellers Joy and possibly before that the Sovereign. In 1857, the pub advertised its 'good dry skittle ground'. The old house was demolished and replaced in 1935 by the present building with its distinctive pantile roof with dormer windows. The architect was William Stewart of London, whose plans show a public bar, private bar and a saloon bar running west to east. Landlord of the 1950s Bill Mendham organised fundraising events for the John Horniman Home for Children. Landlord of the late 1950s to the early 1960s Leslie Waller was a car enthusiast who eventually purchased the Denton Motors garage behind the pub and left the licensed trade to run it as a full-time proprietor. A pint of milk was available on draught keg from the bar here in November 1982. The change of name occurred with a refurbishment of August 2018.

44. Egremont, No. 32 Brighton Road (TO-KTB-CH)

George Greenfield was the principal poulterer of the town and the second landlord of the Royal George. Having left there in 1835 he went on to build this inn and its adjoining brewery. The coat of arms of the Earl of Egremont appears on the building. It became a popular place for functions, such as the East Worthing Fire Brigade supper of 1 January 1890. A Shades Bar was by that time in Warwick Buildings. In 1924, the adjoining Tower Brewery was acquired with its tied houses by the Kemp Town Brewery, who carried out a modernisation of the Egremont. The ground floor was altered and refronted to plans of December 1924 by Denman & Son, while a wine office was added at the south to plans of November 1925. Landlord Harold Sibley was fined for driving without a licence in May 1942. The local branch of the Canadian and United States Parents Association met here in 1957–58. The pub closed for a brief period in 2009–10 before being acquired by local-born Greg Grundy, who oversaw a sensitive restoration that preserved the ornately carved entrance doors and the Arts and Craft leaded-glass windows. Having also had the Kemp Town Brewery signage reinstated, Greg reopened the Egremont in May 2015.

Left: Royal Oak before rebuilding. (Courtesy of Andrew Moulding)

Below: Cow & Oak – formerly the Royal Oak.

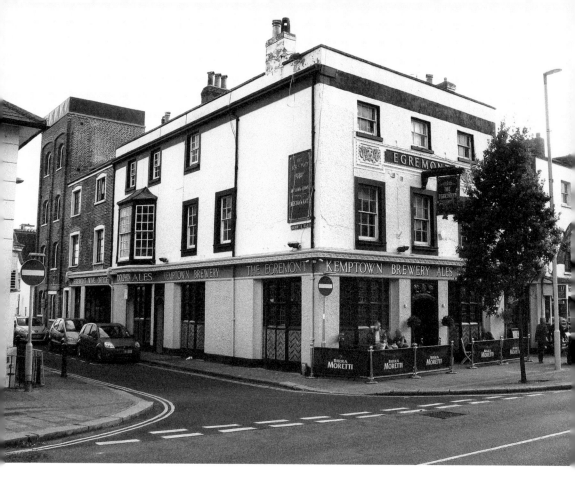

Above: Egremont with rear tower brewery building.

Right: Egremont windows (composite).

45. Warwick, No. 25 Warwick Street (BL-RO-PBU-BR-WH)

This pub has a prosaic rear entrance in Ann Street, where a cabinetmaker's shop became a brewhouse under John Farmer by 1832. William Slaughter began brewing and beer retailing there in 1834 and in August 1847 he successfully applied for an alehouse licence, having requested for a tap to be in Ann Street, with the inn to be entered from Warwick Street and the house to be called the Warwick Arms. The annual supper of the Amateur Boat Club was held here in June 1891, by which time a Shades Bar was in Ann Street. The hotel in 1899 was the headquarters of the Borough Bonfire Society. Charles George May had been landlord here for only a short time before he died suddenly in October 1913, aged thirty-nine. An enthusiastic cyclist as a young man, he had become affected by paralysis and seizures. His wife, Caroline, carried on as landlady until September 1939. A storeroom at the rear was converted to a club and children's room to plans approved in June 1948, by which time the hotel was advertising its shellfish bar. In 1995 it became the Hogshead, part of the Whitbread cask alehouse chain of that name. It reopened as the Warwick after a 1998 refit. Two years later it was expanded westwards into the next-door shop.

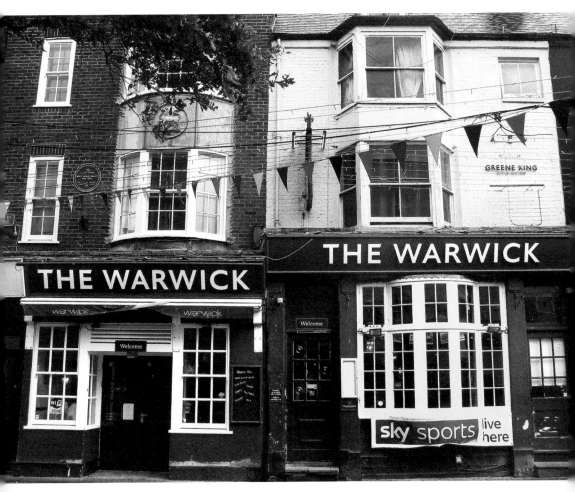

Sky Sports live here at the Warwick.

46. Thieves' Kitchen, Nos 10–12 Warwick Street

The firm that became Roberts & Son wine merchants was established in 1808 and their property here at No. 10 was licensed as the Vintners Arms by August 1836. Even by the early 1920s there was only a wine-tasting counter. Two public bars were subsequently put in, the second of which was called the Thieves' Kitchen as a sardonic allusion to it being the meeting place for traders to talk business. The name assumed popular use after March 1945 and was soon applied to the whole premises. The ground floor was extended into the rear of the shop and former bank at No. 12 to reopen in June 1957 with a new Vintners Bar and a full seven-day licence – the premises previously had to close one hour earlier than normal time and remain shut on Sundays. The extension of the off-licence department into the remainder of No. 12 was completed in April 1965. Roberts & Son sold the premises in 1977 and it was a sign of the times that a new manager, Dennis Pordage, banned around eighty undesirable customers, including punks, Hells Angels and drug users. A 1995 refit by the Magic Pub Co. left the pub with the preposterous name of the Vintners Parrot, which the Worthing Society conservation group denounced as an insult to the Grade II listed building. The parrot was dropped from its perch in January 2014 and in October 2018 the Thieves' Kitchen name was restored after a refit by Greene King Brewery.

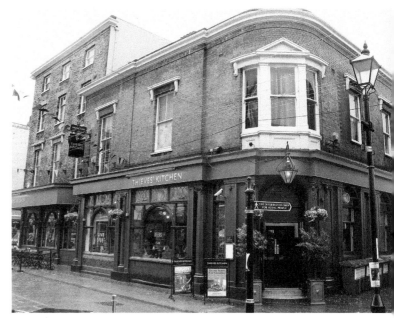

Thieves' Kitchen – originally the Vintners Arms.

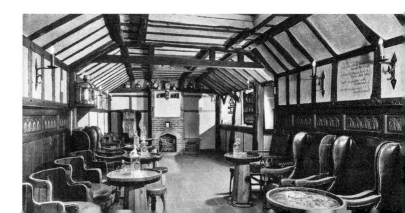

Thieves' Kitchen interior. (Courtesy of Jack Regis)

47. Cricketers Arms, No. 30 Marine Place (TO-KTB)

This beerhouse was known by 1858. During 1868–69, landlord James Branson was a habitual offender against the law that prohibited opening during Sunday divine service. A June 1864 arsonist break-in to destroy the house by a gas leak failed due to there being insufficient fuel in the pipes for it to fully ignite. The house ended up in a congested position and the licence was removed in March 1930 to the new Dolphin Hotel. The brewery then presented the site to the town corporation.

48. Nelson, No. 40 South Street (EA, WG-TA-WT)

The name of this once important commercial inn and hotel was sometimes prefixed Admiral or Lord. It was open by 1802 when the *Prince of Wales* coach ran between here and the Star & Garter at Brighton. The town commissioners held their first meeting here on 13 June 1803. The Worthing Friendly Society, formed in 1805, would assemble outside each May and after attending divine service would parade though the streets preceded by the band before sitting down here to dine. Behind the hotel, in Marine Place, stood the stables and a taphouse. Over the door of the latter was a board advertising 'Fine Purl at 7 o'clock', this being a concoction of warm porter, gin, sugar and spices, also known as Dog's Nose. In August 1828 the taphouse keeper, Thomas Langley, departed for the Goodwood Races, only for his body to be found in Littlehampton Harbour a week later. Both the inn and tap were then one property further seawards at the present No. 38. This changed from the early 1860s when the licence was acquired by Robert Duke Stubbs, who subsequently traded as a wine and spirit merchant at his confectioners at No. 40 and operated a Nelson Shades pub at No. 39 Marine Place. By 1870, the former hotel at No. 38 South Street, now named Nelson House, was a butcher's shop and by 1899, No. 40 was the Nelson Wine Cabin under William Harry Elsworth. It became a pub after his death in 1926, but had to draw its beer from the cellar under No. 38 and retained a connecting rear Shades Bar accessed via Nelson Passage. The Nelson closed at 10 p.m. on Sunday 3 January 1960 under Jack Knighton, to reopen that November as a ladies' fashion shop.

Nelson at No. 40 with first-floor bow window.

UNDER ENTIRELY NEW MANAGEMENT.

The well-known Old House,

THE 'NELSON SHADES,'

(Passage between Mr. Lister's and Mr. Farncombe's, Butcher),

SOUTH ST., WORTHING.

Tamplin's Fine Ales & Stout

ON DRAUGHT.

Wines and Spirits OF THE FINEST QUALITY.

A COMFORTABLE

BAGATELLE ROOM

ON THE PREMISES.

Every Attention paid to all.

Proprietor—W. PAY.

Nelson Shades. (Kirshaw's Worthing Directory, 1894. Courtesy of West Sussex Record Office)

49. Ship, No. 31 South Street

In premises formerly Ferrari's Imperial Restaurant, this opened as the Ship Grill in early-1933 under Mrs Miriam Chapman. It was promptly enlarged to the south by two-thirds of its length through the acquisition of the rear of No. 29. The remarkable galleon frontage was the work of Francis John McGinnity, a master carver of Brighton, solicited though the local Towner Joinery Works. Running along the interior cornice was a row of portholes partially filled with water, in which a wave motion could be started up at the touch of a switch. A feature of the early 1960s was a framed White Ensign over the fireplace, originally flown by Motor Launch No. 160 captained by J. Boyd DSC in the raid on a German submarine base at St Nazaire on 28 March 1942. The pirate figure in his crow's nest barrel atop the first-floor window is known, aptly enough, as Roger. The Ship closed on 28 July 1984 under the Webster family of Essex vintners, who had acquired it in 1955 from John Gardner Ltd of London.

Roger atop the former Ship.

50. Celestial Empire, Ann Street

Referenced by name in 1840, this beershop on the now demolished north side was attached to the Ann Street Brewery, sharing the same proprietor, William Carter. Its customers initially had to stand and drink on the pavement. It was only with passing of the 1830 beerhouse act that a tap and smoking room were fitted and a board placed outside stating 'To be drunk on the premises or not to be drunk' – an instruction that 'presumably referred to the beer and not to the clients', as Edward Snewin wryly remarked in his reminiscences.

51. Dragoon, No. 5 Market Street (TO-KTB-CH)

Known by 1866 as the Volunteer Arms under Joseph Robinson, it was rebuilt to plans of 1908 by Denman & Matthews. Shortly after 2.30 p.m. closing on Saturday 18 June 1927, John Reeds of No. 11 Market Street was knocked down outside the pub, fracturing his skull on the kerb and dying

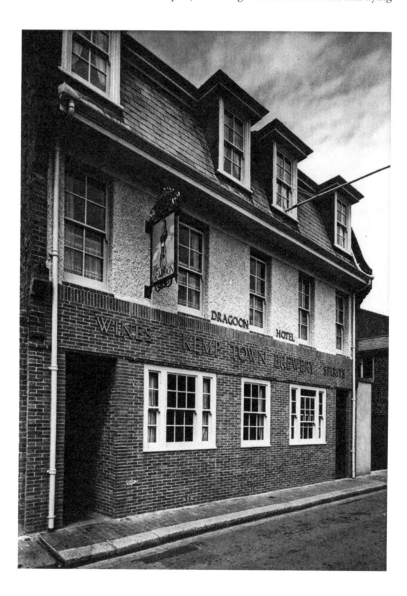

Dragoon – originally the Volunteer. (Courtesy of Jack Regis)

five hours later. He was eating shrimps from a bag when he was struck and a charge of murder was brought against the landlord and former army sergeant, George Ainsworth. A trial verdict of not guilty was found against the reduced charge of manslaughter and the licence was transferred from Mr Ainsworth at the next sessions. Two years later, landlord Harry Snelling was found by a barmaid in the pub kitchen with his head in the gas oven and the taps turned full on. After being revived by a police officer he was charged with attempted suicide. It was perhaps to remove the taint of the Volunteer name that the house became the Dragoon Hotel between 1 May and 9 October 1929.

The landlord of 1960–62, former professional bantamweight boxer Larry Cole-Law was a true Cockney, born within the sound of the Bow Bells. His brother-in-law was former British heavyweight champion Len Harvey. The final hosts were Neil McMurrich and his wife Betty, who fashioned the hotel into a modern jazz venue and popular rendezvous for the theatrical world. With the final bell at 11.45 p.m. on Saturday 17 May 1969, the Dragoon closed for good – or not quite. On the evening of Friday 10 October that year, with corporate permission, a party was held there by Ted Telling to celebrate the first anniversary of the formation of his demolition company. He had won the contract to clear the site for the central redevelopment scheme. Thirty of his workmen and their wives and girlfriends attended. The building was at the time reputed to be haunted by the ghost of a tall man who had met his death in a fight on the pavement outside when the place was a roughhouse.

52. Royal George, No. 29 Market Street (CO-WG-TA-WT)

Probably contemporaneous with the opening of the town market in June 1810, the name is after the warship that sank in Portsmouth Harbour with great loss of life in 1782. From 14 February 1812 until the construction of the first Town Hall in 1835, this was the second meeting place of the town commissioners. The first landlord, George Wingfield, was the grandson of Privateer Nicholas Wingfield who was hanged at Executioner's Dock, London, in 1759. In 1857 the inn had a slate billiard table and covered skittle ground. The then landlord, James Hume, later sidelined on the premises as a mineral water manufacturer. George Henry Hunt and his wife Annie arrived here in 1888 immediately after their wedding reception in Brighton.

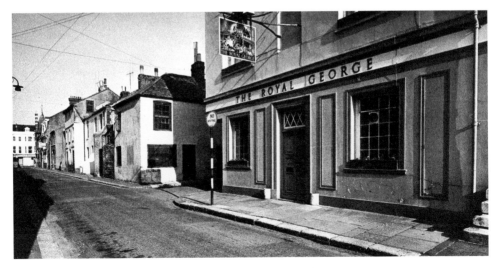

Royal George. (Courtesy of West Sussex County Council Library Service, www.westsussexpast. org.uk, PP-WSL-P003459)

THE ROYAL GEORGE STEAM MINERAL WATERWORKS·

HUME & CO.,

Manufacturers of Mineral & Medicated Waters,

MARKET STREET, WORTHING.

The following are mentioned, with prices affixed, as being generally in demand ; but any Mineral, Ærated, or Medicated Waters can be supplied to order :

SELTZER WATER......3s. 6d. per doz. | LEMONADE 2s. 0d. per doz.
SODA. „ 2s. 0d. per doz. | GINGER BEER......... 2s. 0d. „

THE ROYAL GEORGE

FAMILY & COMMERCIAL HOTEL,

MARKET STREET, WORTHING.

CHOICE WINES, SPIRITS, AND CIGARS.

G. HUME, *Proprietor.*

Steam Mineral Waterworks. (Lucy's Worthing Directory, 1873. Courtesy of West Sussex Record Office)

Mr Hunt spent some years with the town volunteer fire brigade but died suddenly in October 1908, aged forty-seven. His obituary recalled how proud he was to have been chosen by his captain to hoist the royal standard at the saluting point in Windsor Park on the occasion of the Great Review of Fire Brigades by Queen Victoria in 1897. The licence was taken by his widow until her death in March 1944, aged seventy-nine. She had been helped out at the pub by her son Arthur Frederick Hunt, who then carried on until his own death in July 1954, aged sixty. The Royal George closed for the final time at midnight on Wednesday 3 September 1969. In charge for its final few months was ex-Royal Navy officer Ralph Rodgers, who with his wife Jean afterwards moved to the Anchor Inn.

53. Slug & Lettuce, No. 20 Chapel Road

In 1823, the Carter family constructed a brewery on the north corner with Cook's Row. It was subsequently rebuilt a short distance south along Chapel Road and in 1847 began retailing beer on the premises. In 1865, a successful application was made for a spirit licence for what had hitherto been Carter's Brewery but was now to be named the Fountain Inn. It was acquired at auction in March 1892 by Nalder & Collyer's Brewery of Croydon, who had it rebuilt on the present corner site to a design by their local architect Mr West. Popular billiard competitions were held here at the turn of the twentieth century under landlord David Ovenstone, an enthusiast of the game. The house received its brick encasing and rear extension by Frank

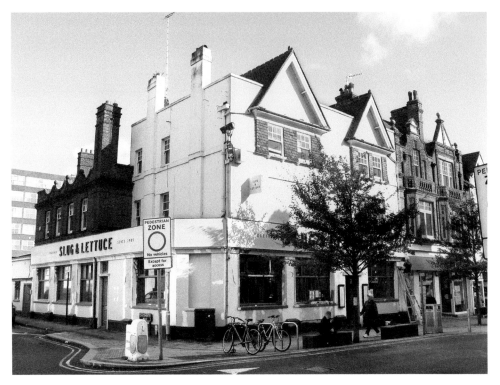

Slug & Lettuce – originally the Fountain.

Sandell & Sons to plans of July 1938 by Croydon architect Charles H. Ridge for Ind Coope and Allsopp Brewery. The interior was also completely reconstructed and a Spanish garden dining room established at the first-floor front. The Fountain was a hang-out for the local fascists at that period but it became popular with Canadian soldiers during the Second World War. The times they are a-changing, and in 1969 the Southern Folk Music Society stopped meeting here after the decision to convert the music room into a disco. From 1997 to 1999 the pub had its own brewkit as the Fathom & Firkin. It reopened as the Assembly on 18 November 2000, became Bar Release on 18 September 2008 and the Slug & Lettuce on 7 October 2016.

54. Cannon, No. 29 Chatsworth Road (KTB)

The Cannon Brewery was open by 1822 in what was then Cook's Row and was retailing beer on site by 1858. A handbill of November 1886 heralded the opening of a Cannon Brewery Museum and Assembly Rooms, which was a grandiose title for the museum of curiosities established there by James Baker. Situated on a turn in the road, the brewery was of squalid appearance in September 1894 when the decision was taken to demolish it along with a row of cottages. It was acquired by Abbey & Son (afterwards the Kemp Town Brewery), whose architects Scott and Cawthorne submitted a plan in September 1895 for a new Cannon Inn on the site. The road was straightened and the new inn faced due south when it opened in April 1896. It promptly became a house where 'some of the worst characters in Worthing were inclined to go'. It closed with the July 1933 transfer of the licence to the new George Hotel in Goring Road and was eventually purchased in 1949 by the owners of the *Worthing Gazette*. The paper then ran an article recalling the Cannon Inn as a place where you 'could get a bucket of beer for twopence

Quaffing from a bottle outside the Cannon.
(Courtesy of Jean Miller)

and a stab in the back for nothing at all'. Or, in the case of Mr Harry Short, who was interviewed for the piece, a stab in the eye. The building was demolished in June 1974.

55. White Horse, No. 29 North Street
This was an end-of-terrace beerhouse run by Henry West and known from 1836 to 1859. The site is now occupied by Lemo UK.

White Horse, far-left property. (Courtesy of Jack Regis)

56. Crown Inn, Chapel Road (EA)

This was open by 1836 on the former site of the house and brewery of Charles Carter Sr. In July 1839, a cricket match between eleven gentlemen in the interest of Charles Goring Esq. and eleven in that of D. Salomons Esq., was played at the ground attached to the inn. The Parade Band performed a selection of popular music before the proceedings and the evening concluded with a dinner provided by landlord Thomas Attree. The inn was succeeded in 1845 by the Railway Hotel, although whether by a renaming or rebuilding remains unclear as a directory of that year provides both the last and first known respective references to the two establishments and under different landlords. Maps show the shape of the property to have been altered during 1838–52.

57. Railway Hotel, No. 39 Chapel Road (KTB-CH)

With the 1845 extension into the town of the railway line from Shoreham, this appears as the aforementioned Railway Hotel under Thomas Henney. There was also a separately run taphouse. In 1865, landlord Henry Norman was advertising 'Flys to let by the hour. Box for hunters & co. Pony chaise. Saddle horses'. In 1906, a motor garage replaced the remaining portion of the stables. The hotel was then run by the Howell family and was closely associated with cricket. Both the Star and Chippingdale clubs held their annual dinners here and it also became the headquarters of the Worthing & District League. The premises were incrementally enlarged by a ground floor extension at the east, *c.* 1912; a north extension and wine office at the north-east, both bow-windowed, *c.* 1926; and a new lobby entrance at the north, 1958. A Ballard & Blues Club opened and met here every Monday from March to September 1962. A change of name to the Lennox Hotel occurred on 29 July 1964 under new landlord Dennis Gates, a survivor of a Second World War sea battle who subsequently spent four and a half years in a prisoner-of-war camp in Poland. In October 1995, under new landlord Jim McSpirit, the pub was renamed the Rivoli after the nearby cinema of that name that had been gutted by fire on 19 January 1960. Life-sized models and wall murals of Hollywood film stars were the main attraction of the saloon bar. The Rivoli pub had been closed since 2002 when at 7.20 p.m. on 7 April 2004 it also became the victim of a blaze. The unsafe remains were promptly demolished. Phoenix House now occupies the site.

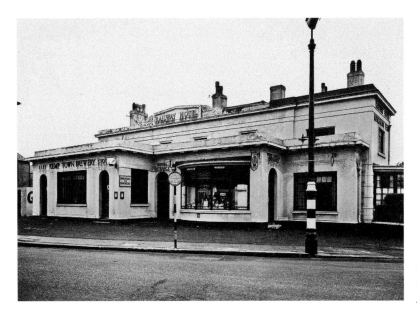

Railway Hotel.
(Courtesy of
Jack Regis)

The Landlords

The son of a Portslade publican, Walter Howell (1859–1923) was a commercial traveller before acquiring the Railway Hotel in 1900, where he appointed his half-brother Jesse (1872–1932) and brother George (1857–1933), manager and tap keeper respectively. Walter was also proprietor of the Pier Hotel for around a decade until his death. His son, Cecil Frank Maurice (1888–1956) was landlord of the Fountain from 1909 to 1919 and of the Railway Hotel from then on until his death, after which the licence was held briefly by his own son, Frank Walter George (1913–2009), before it left the family. Another of Walter's sons, Walter James Harold (1882–1954), was landlord of the Downview Hotel from 1919 until his death, after which his widow Nellie held the licence for a year. The aforementioned Jesse also ran the Montague Arms from 1904 to 1919 and the Albion Hotel from then on until his death. He was succeeded at the former house by his brother Arthur (1869–1927), who remained there until his death.

The Howell family, 1901. (Courtesy of the Howell family)

58. Norfolk, No. 120 Chapel Road (WS-TA-WT)

An alehouse licence was granted in August 1848 to this new beershop, which had a coach house, skittle alley and stables. The latter were still here in 1906 when landlord John Pelling Goodwin kept ducks in a rear paddock. The pub was rebuilt in 1932 to plans by William Stewart of London. Running from east to west was a dining room, off-sales, public bar, private bar and a lounge and dining bar. The landlord at the time was Harry Woodford who became Mayor of Worthing in 1949–50. He was later to run both the Elms and the Ham Hotel. The Picardo School of Dancing (Principal Miss E. Pickard) had its studio here in 1936, while the local Flower Club, Football Supporters' Club, United Commercial Travellers Association and the RAF Association all met here during the 1940s and 1950s. William Russell Wainscoat, landlord of 1952–65 was a former professional footballer with Barnsley, Fulham, Middlesborough, Leeds United and Hull City. Having had various combinations of Inn, Arms and Hotel suffixes, name changes were taken to the extreme when in 1989 it became Flappers with Twenties nightclub, then in 1999 the Space Bar with nightclub Area 51; these were renamed in 2002 as MiB and 3TO (the latter stood for This, That and the Other). 3TO closed for the final time on Saturday 10 April 2004 and in June of that year Anti-G8 protesters opened up the 23TOPIA social centre squat in the former premises. The art deco building was subsequently demolished for the Norfolk House that now occupies the site.

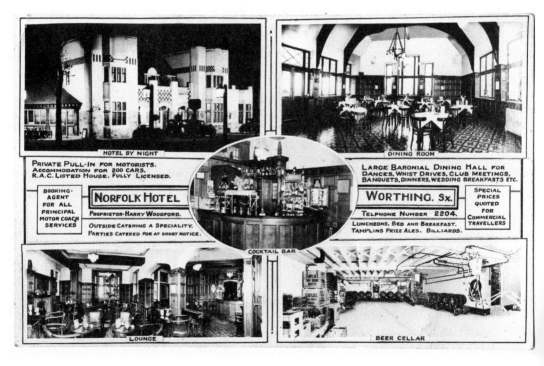

Norfolk Hotel postcard, *c.* 1932. (Courtesy of West Sussex County Council Library Service, www.westsussexpast.org.uk, TC2327)

Space Bar – originally the Norfolk. (Courtesy of West Sussex County Council Library Service, www.westsussexpast.org.uk, Paul Holden Collection)

59. Clock, North Street

Opposite Teville Road and behind the east side of what is now Chapel Road, a malthouse that had existed by 1821 was acquired *c.* 1851 by brothers Alfred and Dennett Allen. It was damaged by fire in May 1854 but was operational again in March 1857 when a surprise visit by revenue officers saw the Allens apprehended for defrauding the excise. A beershop called the Clock then opened in its place, named after the timepiece mounted over the door. After the fine levied against the brothers had been reduced, Dennett Allen returned to the site and began brewing there for four years from 1862, by which time it was called the Railway Brewery and not to be confused with the nearby hotel of that name. In 1876 the site was taken by William Wenban Smith for use as workshops. The clock was remounted on the Wenban-Smith company premises and remained there until 1976 when taken down for restoration by expert Dennis Levene, who dated it to the 1820s.

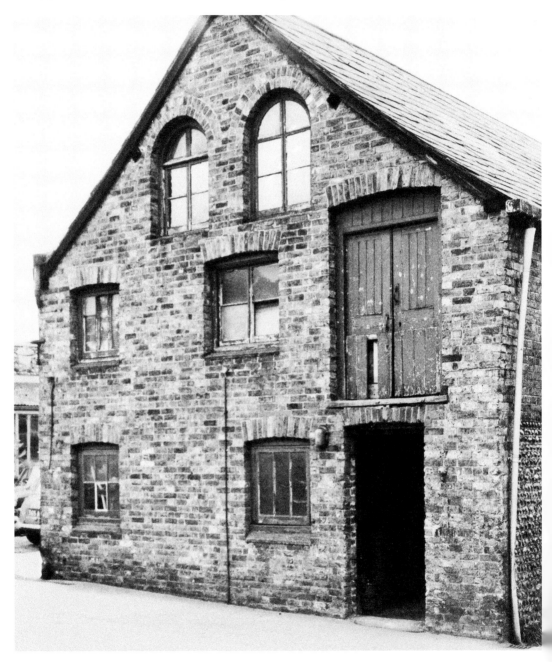

Clock premises, 29 August 1969. (Courtesy of West Sussex County Council Library Service, www.westsussexpast.org.uk, WSL-P005348)

5

Broadwater and East Worthing to the High Street

Starting at Newland Road we promptly take the footpath northwards to Broadwater, where James Tupper ran a beershop in 1838–39 and Thomas Steadman was a beer retailer in 1845. After a detour to Upper Brighton Road we return to the High Street via East Worthing where there once occurred the strange case of the Lily – listed as such at No. 5 Brougham Terrace from 1917 to 1923 in the public houses section of the somewhat unreliable *Pike's G.M.F. Blue Book*. There is no other evidence that occupier Richard Lindup held a licence, yet it is mystifying that he let the error, if that is what is was, continue for so long, given that numerous expectant 'customers' must have turned up at his door.

60. Castle Alehouse, No. 1 Newland Road (TA-WT)
Known by 1870, the gaunt, crenellated building gave rise to the Castle name. The first annual dinner of the Worthing 'Princess Alice' Working-Men's Friendly Society was held here in February 1890. In May 1928, landlord Douglas James Madeley was granted an extension to hold a whist drive supper. Edward Tourle was landlord in the 1940s-50s. His son, Edward Frank became a prisoner-of-war in Stalag XXI after being captured at Dunkirk but was repatriated in 1945 and married two years later. Renamed the Tap & Tankard *c.* 1995, a 1998 change of ownership saw it become O'Connor's Bar - not a themed fake-Irish pub but a genuine real ale venue. It reverted to the Castle Tavern in 2000 with the Alehouse amendment following in August 2016.

61. Globe, No. 73 Newland Road (PO-KTB-CH)
This was known by May 1868 under George Holmes, who the following year opened the Globe South Coast Music Hall on the adjacent corner at what later became the St George's Mission Room. The pub was rebuilt in 1901 to a Queen Anne design by Samuel Denman. Captain Benjamin Dickinson, a master mariner of Southwick, became landlord of the new premises in January 1902 and remained there until his death at the age of eighty-eight in July 1943. The pub closed in late 2012, having retained some of its old etched glass windows showing a taproom once at the west with a bottle and jug along Dagmar Road. By 1947, this latter facility had been replaced by a ladies' room. The melodic trio who performed here in 1974 consisted of landlord Val Savigor on bass, his wife Joan on vocals and local musician Tony Bass on keyboard. The building is now apartments.

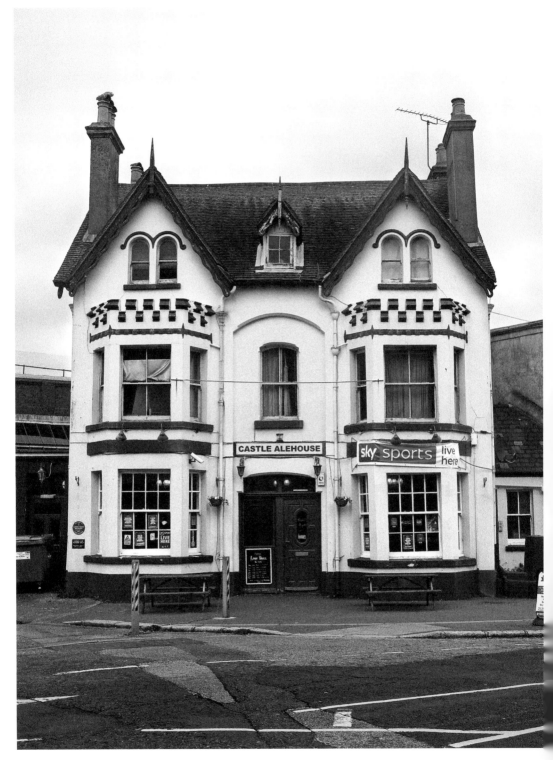

The crenellated Castle Alehouse.

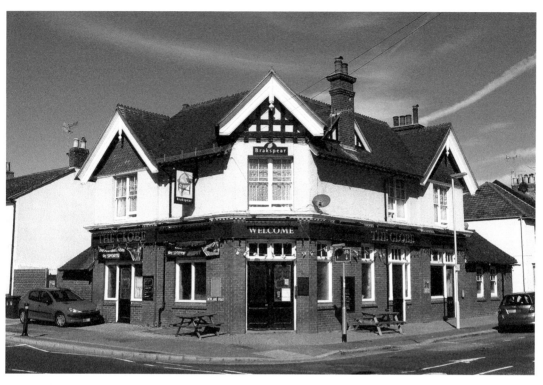

Globe, 8 September 2012.

Etched windows at the Globe.

62. Elms, No. 66 Broadwater Street East (TA-WT)

This was built in 1927 to a design by Arthur Packham on the site of the former Elm Villa that took its name from the elm trees that grew there. A private bar was at the south and a public bar was at the north with a small ladies' bar secluded behind. The Elms opened as a beerhouse in February 1928 under Ernest Thomas Cobby, who received a full licence in February 1929. The Royal Antediluvian Order of Buffaloes (Charmandean Lodge No. 7,089) was established here by 1934. The Worthing Royal Artillery Association held their annual meeting here in February 1955. Weekly raffles organised by customers raised over £1,000 in October 1980 to purchase two external pacemakers for the hospital. New signage of 2013 proclaimed this to be 'Worthing's premier music venue', but it had closed by July 2016 and the following year was converted to flats.

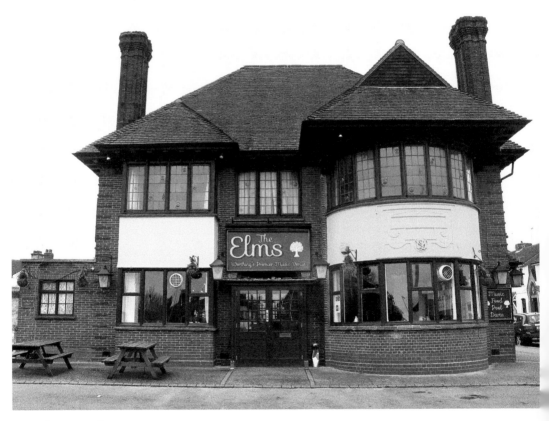

Elms, 4 April 2015.

63. Old House at Home, No. 77 Broadwater Street East (TO-KTB-CH)

Richard Apted was selling beer at his bakery on this site in 1832 and his son James was brewing there *c.* 1858. The name, first recorded in 1880, was after what became its 'anthem', sung here on Saturday nights by a little Irishman. Very different from the two sentimental nineteenth-century ballads of that title, its lyrics were as follows:

On Monday I goes out with Rosy,
On Tuesday I goes out with Jane,
On Wednesday I goes
with a widow I knows
and her kids follow on down the Lane.
On Thursday I goes out with Ryah,
and Friday I practice the choir,
but on Saturday night I get tiddly-tight
in the Old House at Home by the fire!

The flint cottage premises were replaced by the present building to plans of January 1925. The projecting lobby entrance gave access to a bottle and jug with public bar at the west and bar parlour at the east. A wine licence was granted in February 1929 and a full licence twenty years later. In 1950, the public bar was extended at the rear and the saloon bar (originally the tenant's sitting room) enlarged into the bar parlour.

The Architects

John Leopold Denman (1882–1975) was the son of Samuel Denman and in 1909 he took partnership in his father's practice at No. 27 Queen's Road, Brighton. He was later in partnership there as Denman & Son with his own son, John Bluet Denman. A fellow of the Royal Institute of British Architects and a founder member of the Architecture Department at the Brighton School of Art, John Leopold Denman became in-house architect to the Kemp Town Brewery. It was

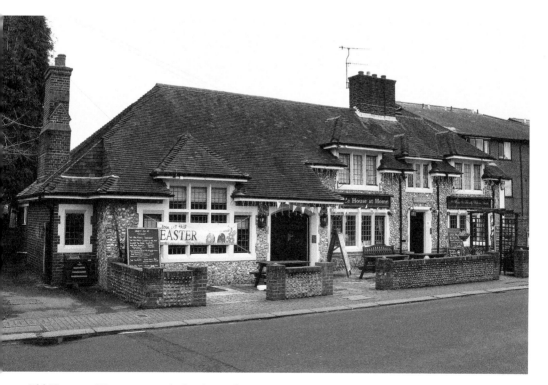

Old House at Home – named after its 'anthem'.

in that latter capacity that he designed the majority of that brewery's improved public houses, occasionally in the vernacular style, as with the above Old House at Home, or in his trademark neo-Georgian, as in the Ham Hotel, now the Smugglers Return.

64. Broadwater, No. 4 Broadwater Street West (TT-ST-RO-PBU-BR-WH)

This was the Maltsters Arms by February 1785, although an inn was on or near this site in 1690 and William Humphrey, a maltster, was the occupier in 1752. It was briefly, in 1828, called the Millwrights Arms. The landlord of the mid-1890s, Walter Wardroper, and his brother Henry were music hall impressionists. The pub was rebuilt to plans of May 1934 by local architect Arthur J. W. Goldsmith. A curved wine office formed the north-west corner, with a saloon, private bar and a public bar running along to the south-east. It was probably the rear club room that was adapted as the special table tennis room in the 1930s to 1950s. The local Triumph Owners Motor-Cycle Club met here on Wednesdays in 1956. The Troubadours folk club held weekly Sunday evening sessions here for a year from March 1966. The pub officially opened under its present title of the locality on Friday 26 June 1987. The first pint was poured by local pet shop proprietor Paul Gibson, who had won the competition to suggest a new name. The new sign of 2005, by local painter Nick Hallard, portrayed a monk getting a dousing on the ducking stool that was once on Broadwater Green. Nick had to retouch its features after Greene King Brewery, owners since the previous August, discovered that they were those of Deputy Prime Minister John Prescott, who wanted houses to be built on Greenfield sites in the area.

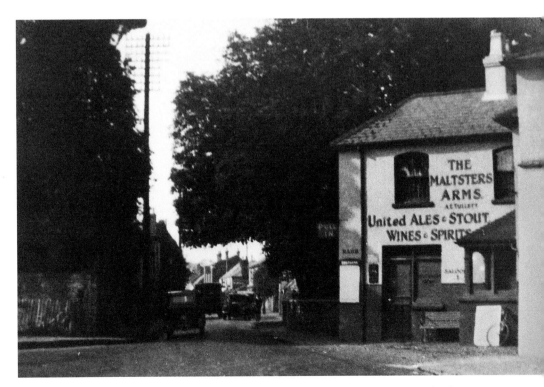

Maltsters Arms before rebuilding. (Courtesy of West Sussex County Council Library Service, www.westsussexpast.org.uk, WSL-P004123)

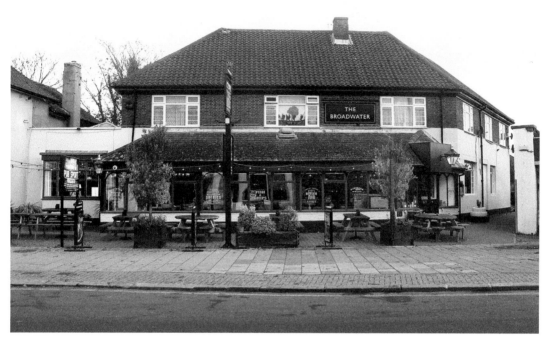

Broadwater – formerly the Maltsters Arms.

65. Cricketers, No. 66 Broadwater Street West (PO-KTB-CH)

We are fortunate that the 1962 construction of the Cricketer's Parade shops and car park did not necessitate the demolition and reconstruction of this pub as had first been intended. A beerhouse was on the site by August 1853 under former lodger-turned-brewer owner Thomas Luff, who three years later was granted a spirit licence for his Brewers Arms. He put it to sale at auction in 1872 and it was a former civil servant, William Penley, who reopened it (probably rebuilt) in June 1874 as the Cricketers Arms and offered 'all the necessary implements at a moderate price for those wishing to play the game on the common facing the house'. In the 1890s, landlady Margaret Jane Medlock established a tearoom here and catered for 'Cricket Luncheons, Beanfeasts and Pleasure Parties'. Bombardier Billy Wells trained on these premises in 1913 for his heavyweight boxing match against Georges Carpenter. Contrary to common assumption, General Montgomery did not stop off here for sandwiches during the Second World War – it was actually his stand-in, local repertory actor Clifton James. The purpose of the performance was to mislead the Germans over the timing and location of the Allied invasion of Europe, but it was not only the Nazis who were taken in. James addressed an assembly of troops, including Montgomery's own 'Desert Rats' veterans, while standing on the bonnet of a jeep on Broadwater Green, and then made an official visit to the mayor at the Town Hall, without anyone realising that this was 'Monty's Double'. On 31 January 1989, landlord Wilf Page died, aged sixty-four, and over 500 people attended his funeral. He had taken over on the death of his father in 1946, although the licence had been in his family for over a century by way of his mother's first marriage having been to the third son of the aforementioned Mrs Medlock.

"THE CRICKETERS' HOTEL,"

BROADWATER GREEN.

W. B. PENLEY,

PROPRIETOR,

(Late of H.M. Civil Service).

WINES, SPIRITS, ALES,

TOBACCO AND CIGARS,

OF THE BEST QUALITY.

ACCOMMODATION FOR LARGE & SMALL PARTIES.

DINNERS, LUNCHEONS, &C.

Everything connected with the Game of Cricket
on Hire.

Cricketers Hotel. (Kirshaw's Worthing Directory, 1875. Courtesy of West Sussex Record Office)

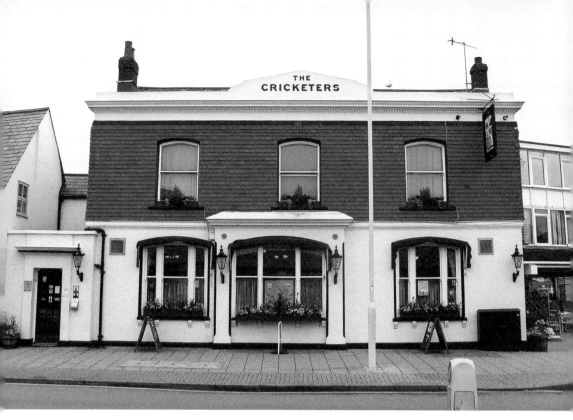

Cricketers – originally the Brewers Arms.

66. Engineers Arms, No. 69 Broadwater Street West (TA)

Beer retailer, baker and grocer Robert Stather was trading here by 1870. The name is first recorded in 1880, after the neighbouring general engineering company of Paine & Manwaring. After closing up at 10 p.m. on Saturday 20 February 1897, the landlord, Loyal Brown Boniface, sat in the kitchen fireplace chair and shot himself in the forehead with a pistol. A verdict of suicide while temporarily insane was recorded at the inquest. This beerhouse closed in February 1928 when the licence was transferred to the newly built Elms. The site was eventually absorbed by the expansion of the engineering company premises and this part of the street has since been renamed Ardsheal Road.

67. Toby Carvery Downlands, Upper Brighton Road (PBU-BR-WH)

Built by Messers Lovell Ltd of Eastbourne to a design by Goldsmith & Pennells, the Downlands Hotel opened at 6 p.m. on 2 August 1939 under former London publicans Mr and Mrs Pemberton. Running from west to east was a public bar, private bar, off-licence and lounge bar. A grill room and a children's room were at the rear. The Worthing Archery Club held their annual dinner here in November 1962. Dancing classes – Disco and Hustle, Ballroom and Latin – began here on Tuesdays in April 1980, the same year that the pub became part of the Beefeater chain. As a Toby Carvery outlet, it now does a roaring breakfast trade.

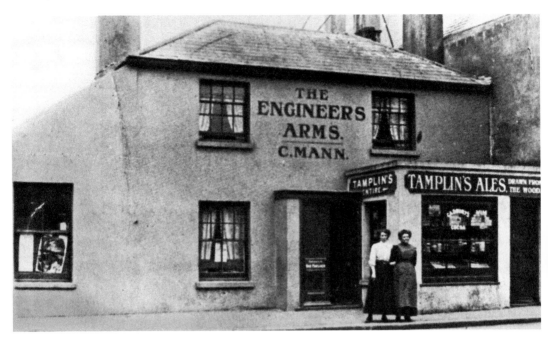

Engineers Arms, *c.* 1911–17. (Courtesy of West Sussex County Council Library Service, www.westsussexpast.org.uk, WSL-P003911)

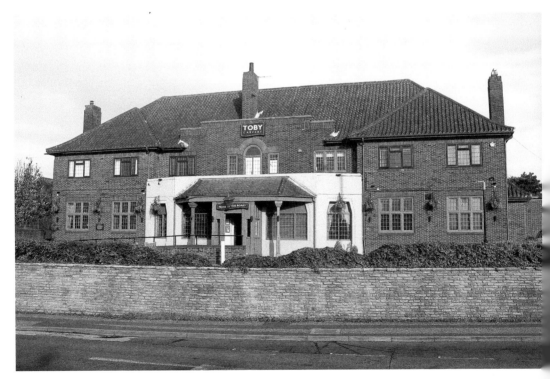

Toby Carvery Downlands – opened as the Downlands Hotel, August 1939.

68. Wigmore Arms, No. 37 Wigmore Road (RO-PBU-BR-WH)

The site was purchased in 1913 and the premises erected the following year to plans by Stanley Towse of London, but the February 1915 application for a licence was refused and attention was then distracted by the First World War. In 1924, the brewery was approached to let the building as a club but they persevered instead with their original intention for a pub, which, after some modification of the building to plans by Stavers Hessell Tiltman of Brighton, finally opened in July 1925 and named after Robert de Mortimer, 6th Baron Wigmore. At 11.40 a.m. on Monday 29 January 1941, a pale and silent James Virrels was served a double rum by manager John Turrell. Virrels had just come from his lodgings in Kingsland Road where he had killed his landlady in an argument, stabbing her forty times then striking her five times with a hatchet. He was hanged on 26 April that year. In April 1985 the tenancy was taken by ex-England footballer Malcolm Macdonald. The name was changed to the Far Post and a £50,000 refit saw the traditional compartmentalised interior transformed into a single sports bar, while the gourmet cooking of his wife, Nicky, saw them rewarded by an entry in the 1987 *Egon Ronay Pub Guide*. The name reverted to the Wigmore Arms on their departure that year, but in 1997 it became the Wig & Pen following a refit under incoming landlord Peter Fake. The pub closed in early 2005 and was demolished for the Charter Court that now occupies the site.

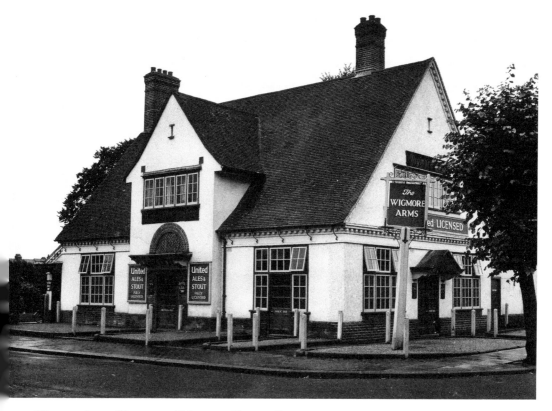

Wigmore Arms. (Courtesy of Margaret Sheppard)

69. Dolphin Hotel, Dominion Road (KTB-CH)

This newly built hotel to a Denman & Son design opened in March 1930 with a private bar, bowls room, refreshment room, club room and public bar, but with only a beerhouse licence. It would be three years before a glass of wine could be enjoyed here, while a full licence was not granted until May 1939. Determined temperance opposition had held sway. Allegations by activists had been made about increased rowdiness in a poverty-stricken area; the suggestion was put that a wine licence would enable men to entice women into the hotel bar, while a local reverend had been moved to quote from John Wesley: 'Sellers of spirituous liquors are poisoners-general, murdering His Majesty's subjects and driving them to hell like sheep.' Quite different religious doctrines were eventually to achieve supremacy here.

The first landlord, Ernest James Gomm, failed to return from a shopping trip to Brighton on Thursday 29 May 1930. Three weeks later his body was washed ashore 40 miles to the east at Pett Level. It was thought he had boarded a pleasure steamer and an open verdict was recorded at the inquest. Tuesday 9 September of that year saw the opening day of miniature golf in the hotel grounds, while illuminated gardens to which children were admitted were the attraction of May 1950. May 1958 saw the commencement of Sunday evening Mass in the hotel lounge, a provision that continued until the Roman Catholic Church of St Charles Borromeo opened in 1962. A 'Vicars and Tarts' night took place at the pub on 12 November 1982. The Dolphin closed in 2013; its licence expired on 28 January 2014 and the premises were converted into a convenience store.

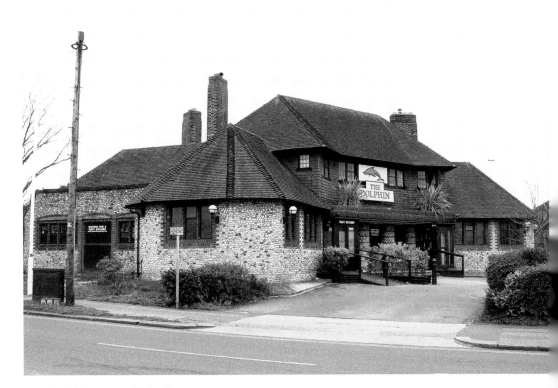

Dolphin – opened March 1930.

70. Smugglers Return, No. 112 Ham Road (KTB-CH)

This newly built improved public house opened as the Ham Hotel in 1926 under Captain Frank Dickerson. A public bar, jug department, private bar and wine office ran west to east along Brougham Road. The charitable organisation Ye Ancient Order of Froth Blowers was soon convening in the rear club room. Captain Dickerson left in 1931 to be replaced by his brother-in-law Bill Jenvey, who revived the sport of shove ha'penny in Worthing after the Second World War. Mr Jenvey died on the premises in October 1960 and was succeeded to the licence by ex-mayor Harry Woodford, whose wife Maud was to die on the premises in August 1962. In a romantic renaming of November 2004, this modern inland pub became the Smugglers Return.

Smugglers Return – originally the Ham Hotel.

Smugglers Return interior.

71. Half Brick, Nos 221–223 Brighton Road (ST-RO-PBU-BR-WH)

A beerhouse was opened by James Shepherd of Navarino Mills by August 1836. It is recorded in the 1841 census as the Brewers Arms but had been referred to in bench proceedings of the previous August as the Half Brick under local brewer-owner Henry Mitchell. It suffered sea damage in 1850 but was trading the following March under brickmaker-landlord John Venn. A three-day storm of January 1869 caused its second, more complete, destruction; yet it was open again in July 1871, having already been recorded in the census of that year. A third flooding with great force occurred in November 1875 and a sale notice of the following July advised that the buyer would have to rebuild the house. This occurred after its July 1879 purchase by the Steyning Brewery. On 19 May 1932, landlord Congdon Robert Sibun died at sea on the paddle steamer *Waverley*. On 28 May 1968, landlord Fred Kettle, the oldest in the town, celebrated his ninetieth birthday. A less popular figure was manager Leonard Coller, who between October 1976 and February 1978 banned numerous regular customers for making trivial complaints. They retaliated by successfully petitioning the brewery for his sacking. Singer and harmonica player, Bob Brookes, was the last licensee. He had turned the pub into a popular live music venue, but resigned in April 2009. The pub never reopened and the incorporation of part of the building into flats called Shoreline Court was complete by 2013.

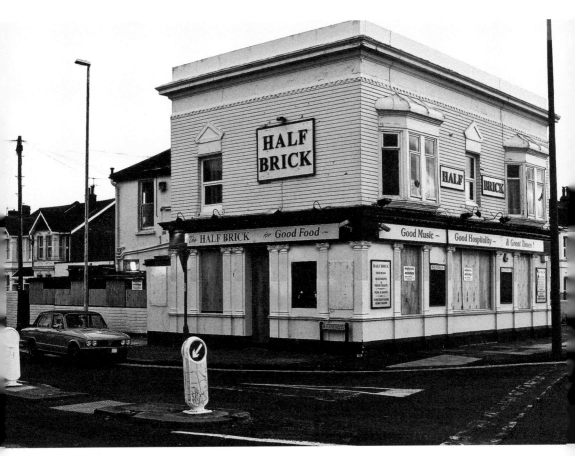

Half Brick, 18 May 2010. (Courtesy of Dick Pike)

72. Alexandra, No. 28 Lyndhurst Road (TO-KTB-CH)

This was known by 1871 under William Howard. The landlord of 1886, Thomas John Martin, was sentenced to five years in prison for, on 8 January that year, having 'assaulted and ravished' Louisa Shopland, aged just fifteen and a half and in his employment. On 8 January 1901, the landlord for some ten years, William Cole Sr, aged sixty-six, was departing a bank in South Street when he suddenly staggered in the porch, leant against the wall for support, then slowly sank to the ground and died. His faithful fox terrier could not be dissuaded from dashing distractedly about the site after the body was removed. The pub received a remodelling in classical style, probably to plans submitted in April 1899 but which have not survived. In June 1904 a Quoits Club was founded here by landlord Horace William Symonds. Over fifty years later, landlord Richard Thomas Davies was being told by his 'old-timers' how the game of quoits was once played out at the back and beer was taken in buckets to the players. This was an all-female-staff pub in 1984 under landlady Margaret Benn.

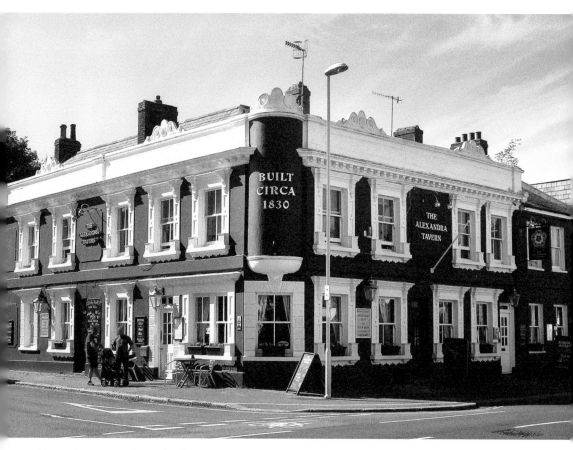

Alexandra – certainly not built *c.* 1830.

73. Selden Arms, No. 41 Lyndhurst Road (BL-RO-PBU-BR-WH)

The August 1867 granting of a licence to James Baker for a house he was erecting in this road is the probable origin of this pub, although the first reference by name is in 1870 under landlord Thomas Lewis. A smoking concert was held here in June 1905 under the auspices of the Selden and Excelsior Slate Clubs. Herbert Brunton became the landlord in 1913 after having served in the army for five years at Cairo. Aside from a brief call up for military service in 1918 he remained the licensee until the Second World War, when his eldest son, Edward, took over. It was thought that Mr Brunton Sr decided to move elsewhere because the Selden Arms was too close for comfort to the town gasometers, a prime target for the German bombers. If this is true then his fears were justified, for on 8 October 1940 the pub had a near miss when the two houses just three and four doors to the west were destroyed in exactly such a raid. A free house since the late 1970s, the Selden Arms was voted Arun & Adur CAMRA branch Pub of the Year seven times in the decade 2000–09 under Michele Preston and Bob McKenna.

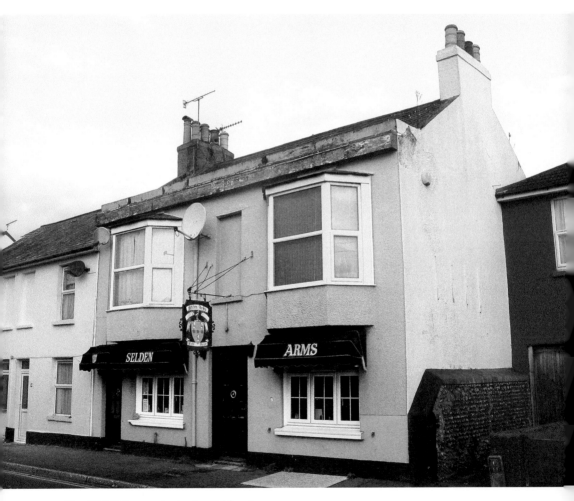

The CAMRA award-winning Selden Arms.

74. Corner House, No. 80 High Street (TA-WT)

As the Anchor, this was one of the 'three good inns' of Worthing recommended in volume four, part two of the *Universal British Directory* of *c.* 1798, although it was the Golden Anchor in 1823. The name may not be nautical but derive from the word anker, a north European measure of spirits. Land in the town could once be purchased for a little as 'half an anker' – around 5 gallons of brandy. On 22 February 1832, William Cowerson was shot dead after his smuggling gang was confronted in the High Street by the Preventative Force. The landlord, George White, received a pound for the use of his room for the inquest. The inn then had a walled front garden and an extensive open area at the rear used for archery and feats of horsemanship by travelling circuses. The convenient location ensured that the grounds were also a popular refuge for vagrants.

The present house is a rebuild of *c.* 1895. Albert Victor George Gordon, who retired as landlord in 1955 after twenty-three years here, had taken over from his father, Albert J. Gordon, who became licensee in 1912. In those days, customers who purchased a penny screw of shag tobacco were given a clay pipe in which to smoke it, Mr Gordon Jr reminisced. All changed with his successor Ernie Rofe, who had a liking for electric organs despite not being able to play a note. Having had one installed at the Anchor in August 1958, at a purchase cost of 560 guineas, he entrusted the performances to Johnnie Matthews, who had only so far played the piano but wanted to try his hand at something new.

In October 1988, the Anchor was renamed the Jack Horner (for it sits on a corner) after a £60,000 facelift under new landlord Michael Glasby who said 'there has to be change and this pub has been brought up to date'. More was to come with Nick Heryet, who on 13 August 1999 outdid the solar eclipse by officially opening the Jack Horner as Worthing's first openly gay pub. Nick attracted a high volume of custom though weekly drag acts and karaoke nights. Another change of ownership saw another name change on 15 August 2011 to the Stage. It was purchased again in 2015, smartly renovated and reopened in October that year as the Corner House.

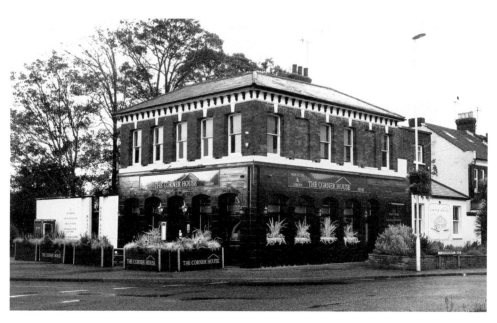

Corner House – originally the Anchor Inn.

75. New Amsterdam, No. 79 High Street (TO-KTB-CH)

Until recently called the Swan Inn, it was intermittently the White Swan and was so in its first known recording by name of 1838 when it was described as 'a resting place for casual visitors to the town'. It was also a beerhouse. The proprietor, William Lucas, had been fined in October 1836 for the unlicensed selling of spirits. During the 1885–95 tenure of James Stone, it acquired a reputation for being unclean. Yet in a letter to the local press Mr Stone vowed 'to remove the slur falsely cast upon the Swan'. A report made by the Sanitary Inspector following a visit to his house, Mr Stone described as 'framed allegations against me'. The statement that the accommodation was overcrowded with no segregation of the sexes could not be sustained, argued Mr Stone, because the inspector did not enter the sleeping apartments but merely looked in with the aid of a lamp. The inspector had already withdrawn the accusation that he was met with foul and abusive language. As for the complaint that the dog had been set upon him, the inspector would have been aware that the police superintendent who had accompanied him had remarked on the harmlessness of the animal and that it did not in the least frighten him.

In May 1938 the inn was modernised and refronted to a design by F. W. Pearcy – the original house dated back to *c.* 1790. The public bar was enlarged by the incorporation of a rear disused lodging house mess room, while a bottle and jug and small private bar were established at the front left. It was during these renovations that a set of four brass medals commemorating the life and death of Princess Charlotte – she had visited Worthing in 1807 and stayed at Warwick House – were discovered in the wall of a rear outbuilding and bequeathed to the town museum. The landlord at the time was Ernest John Dean, in whose family the beerhouse licence had been since the turn of the century. He was granted a wine licence in May 1939. A full licence was finally granted in February 1952 to Roy Lionel Cook. In the early 1980s, this was a tied house

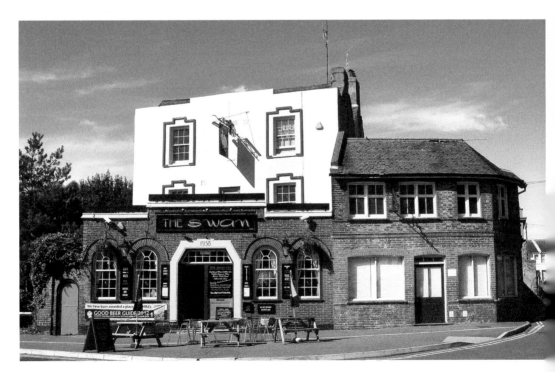

Swan – now the New Amsterdam.

of the King & Barnes Brewery of Horsham. Regulars at the Swan in 1983 included the eight man and one woman Diamond Edge parachutist team. In June of that year they completed a 5,000-foot charity jump into the sea off Worthing. The pub reopened in March 2019 under new owners and with its new name, the old name for New York.

WS (White Swan) window at the New Amsterdam.

Bibliography

Primary Sources
West Sussex Record Office
Broadwater Highway Rate Book 1861–68, BO/WO/35/8/2
Worthing Borough Council Building Plans, BO/WO/16
Worthing Borough Council Highways Committee Minute Book, March 1897 – April 1900, BO/WO/3/2/3

Worthing Library Local Studies
Broadwater Highway Rate Book 1824–28
Broadwater Parish Church Rate Book 1818–24
Broadwater Surveyors Rate Book 1818–22
Inns and public houses file
Local directories and newspapers

Secondary Sources
Davies, Roger, *Tarring: A Walk Through Its History* (Tarring, 1990)
Davies, Roger, *The Copyhold Tenements of West Tarring 1650–1900* (Tarring, 1990)
Dore, Jane, *Edwardian Durrington & Salvington* (Goring-by-Sea: Verité CM Limited, 2016)
Edmonds, Antony, *Lost Buildings of Worthing: A Historic Town and Its People* (Stroud: Amberley, 2016)
Elleray, D. Robert, *A Millennium Encyclopaedia of Worthing History* (Worthing: Optimus Books, 1998)
Hare, Chris, *Historic Worthing: The Untold Story* (Adlestrop: Windrush Press, 1991)
Holtham, Peter, 'The Brewers of West Sussex', *Sussex Industrial History*, No. 34, pp. 2–11 (2004)
Kerridge, Ronald G. P. & Michael R. Standing, *Georgian and Victorian Broadwater* (Chichester: Phillimore, 1983)
Kerridge, Ronald & Michael Standing, *Worthing: From Saxon Settlement to Seaside Town* (Worthing: Optimus Books, 2000)
Rowland, A. M. and T. P. Hudson, *A History of Worthing* (Chichester: West Sussex County Council)

Smail, Henfrey, *Worthing Pageant: The Worthing Map Story* (Worthing: Aldridge Brothers, 1949)

Snewin, Edward & Henfrey Smail, *Worthing Pageant: Glimpses of Old Worthing* (Worthing: Aldridge Brothers, 1945)

The Friends of Broadwater & Worthing Cemetery, *Publicans and Hoteliers (1)*, Booklet 10, 2012; *(2)*, Booklet 11, 2012; *(3)*, Booklet 32, 2016

Various Authors under the Worthing Art Development Scheme, *Worthing Parade Number Two*, (Worthing: Aldridge Brothers, 1954)

Newspapers and Magazines

Sussex Drinker: Magazine of the Sussex Branches of the Campaign for Real Ale, 1996–2019

Worthing Journal, 2011–2019

Worthing Sentinel, 2000–2010

Websites

Ancestry, www.ancestry.co.uk

British Newspaper Archive, www.britishnewspaperarchive.co.uk

Find My Past, www.findmypast.co.uk

Old Worthing Street, www.oldworthingstreet.com

Worthing Pubs History, www.worthingpubs.com

Acknowledgements

The authors would like to thank the very knowledgeable and helpful staff at the West Sussex Record Office and the Local Studies section of Worthing public library. Our grateful thanks go particularly to Martin Hayes, County Local Studies Librarian, for his help in sourcing some of the older photographs. Photographs were taken by the authors unless credit is otherwise acknowledged. Every attempt has been made to seek permission for copyright material used in this book. If copyright material has, however, been used inadvertently without permission then we apologise and will make the necessary correction at the earliest opportunity.

About the Authors

David Muggleton is from Leicester but undertook his undergraduate degree at the University of Sussex and has lived and worked as a lecturer and writer in West Sussex since 1997. His previous books with Amberley Publishing are *Brighton Pubs* (2016), *Brewing in West Sussex* (2017), *Chichester Pubs* (2017) and *Bognor Regis Pubs* (2019).

James Henry, although not Worthing born and bred, has been resident there for over forty-five years. He classes himself as a bit of an amateur local historian after developing an interest in the history, development and later loss of Worthing's old pubs – see www.worthingpubs.com.

Colin Walton has lived in Worthing all his life and has a degree in History and Archaeology. He is a Worthing Heritage Tour Guide and a collector of local history books with a specific interest in Worthing pubs. He and James are co-authors of *Secret Worthing* (2016), also by Amberley Publishing.